VISIBLE SIGNS →

DAVID CROW

contents

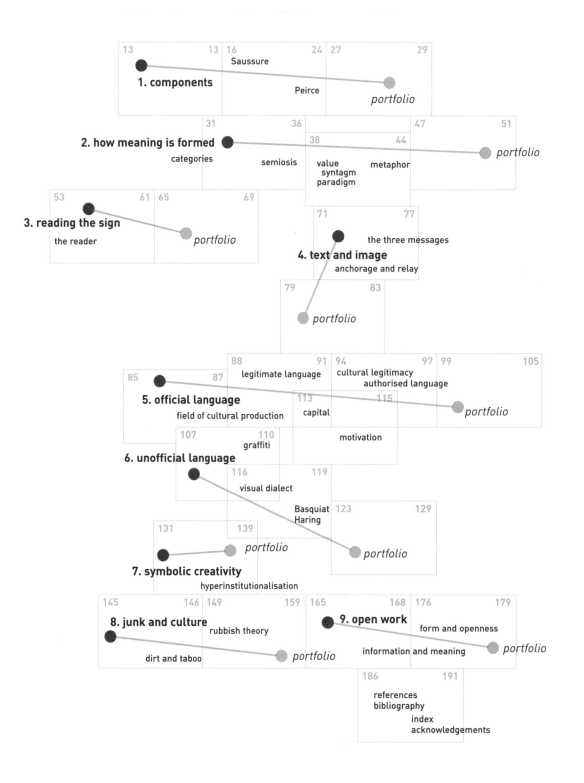

The aim of this book is to explore the mechanics of visual language in an attempt to help you understand how visual communication works. The various practices that make up the visual arts have no theory of their own. The terms and theories that are used to explain visual communication are borrowed from the study of language (linguistics) and the science of signs (semiotics). This can make it difficult to relate these ideas to the wide range of visual signals we understand as visual arts. 'Visible Signs' features a range of contemporary examples of art and design and helps to explain how they work by applying the ideas and theories outlined in the text. These theories are neither independent nor definitive. Rather, there is a range of ideas that inform these studies that are constantly being reviewed, extended and developed. It is not possible to cover all these ideas in a single publication so this is inevitably a personal edit of the ideas and theories that I have found interesting and useful. It is a slice through the many writings on the subject of semiotics, and an attempt to draw some of these ideas together showing something of the synergy between them.

As consumers of visual art we have become highly sophisticated readers of signs and signals. We decode meaning from compositions with subconscious ease. It is important for artists and designers to have an understanding of how meaning is formed and the way that readers can be led to meaning through the juxtaposition of words and

images, our visual language. Our desires and our sense of our own identities are all moulded and manipulated by the signs which surround us. Language also has inbuilt political meaning.

'Except for the immediate satisfaction of biological needs, man lives in a world not of things but of symbols.' [1]

It can be used as an instrument of control. Communication has a hierarchy that is deeply embedded in our societies. All of us carry attitudes, learnt over the years, which organise communication into systems of differences. Our attitude towards a speaker is often illogically bound up in our attitude to a way of speech. This is also true of visual communication. Different media carry different meanings for us regardless of the content of the messages. The way we 'speak' can be separated out from the language system we use and in many cases it is this 'voice' which is the important part of the message. What is acceptable communication in one setting may be wholly unacceptable in another.

We will look at 'authorised' and 'legitimate' language alongside semiotic theory in an attempt to outline the context in which a piece of communication might characterise itself as official or unofficial. We will look at the ways in which this visual stimulus is coded and explore the reading of visuals that appear out of their expected context.

By looking at the effects on unofficial communication when it is transferred across a range of 'official' media we will explore to what extent images acquire their meaning from the way they are represented and the context in which

they appear. This also involves an attempt to clarify the intention behind specific modes of unofficial communication such as graffiti and to compare this to the way this material is read by those who are not involved in making the imagery.

The hierarchy of visual language spans the full range of cultural and economic activity. The majority of people in our societies are familiar with advertising, comic books and television yet these are often regarded as 'low' culture despite their popularity. The 'high' art activities in galleries and theatres are consumed by a relatively small minority. We will discuss this apparent distance between the consumer and the 'fine' arts and the ways in which visual language can be used to transfer objects and visuals across these perceived boundaries.

The motivation behind this publication comes from a personal concern that is shared by many designers, artists and teachers. What is the role of the artist/designer? For some time now there have been many criticisms of a field which may have been guilty of being overly concerned with purely commercial matters. It has been difficult at times to see how this has benefited anyone but a select few. For example the designer boom of the 1980s left many designers feeling almost embarrassed to be included and at times the industry seemed to have lost sight of what might be called its social or cultural functions. As a result the general public became suspicious or cynical about design and the 'designer' label became something to be wary of.

1. Von Bertalanfly L.
General Systems Theory
(1968), Braziller in
Bolinger D. *Language the
Loaded Weapon* (1980)

2. Brody N. at the 1990
Graphic Directions
Conference, London in
Eye Magazine No. 1 Vol. 1
(1990)

To many it was seen as a signal of being overcharged for a product or a service which had a superficial value acquired purely through branding. This was clearly a concern for a number of artists and remains so today. 'Visible Signs' looks for the possibility of a visual language which already exists, growing from its own resources, used by a large group of people who could be said to be outside the arts and media. An informal visual language which does not use the economic field as its source of rationale. To this end we will discuss the notion of 'symbolic creativity' and its use by individuals in finding ways of visually representing their identities. We will look at the possibility for changing the value of objects and images in 'Junk and Culture' and celebrate the creative relationship between the author and their audience by looking at 'Open Work' in the visual arts.

'There is no longer any potential in the design industry for humanistic thought. The industry no longer represents or deals with what we might term "real" or everyday life. It no longer speaks for or even to the people...No one talks about people any more, only "shares", "turnover" and "target markets"...the public has had to tolerate endless redesigns carried out purely as a business investment, as a means of giving form to invisible assets.' [2]

components

1

What is a theory?

The word 'theory' comes from the Greek word 'theorema' meaning to view, to observe or to reflect. The dictionary defines theory as an explanation or system of anything: an exposition of the abstract principles of either a science or an art. Theory is a speculation on something rather than a practice.

The theories which we apply to graphic design and visual communication are taken from a study of the general science of signs known in Europe as semiology and in the USA as semiotics.

This new science was proposed in the early 1900s by Ferdinand de Saussure (1857–1913), a Swiss professor of linguistics. At around the same time an American philosopher called Charles Sanders Peirce (1839–1914) was developing a parallel study of signs which he called Semiotics. To avoid confusion we will use the term semiotics as it has become more widely known. Although they were working independently there were a number of fundamental similarities in both of their studies. Both Saussure and Peirce saw the sign as central to their study of semiotics. Both were primarily concerned with structural models of the sign which concentrated on the relationships between the components of the sign. For both Saussure and Peirce it is this relationship

Saussure

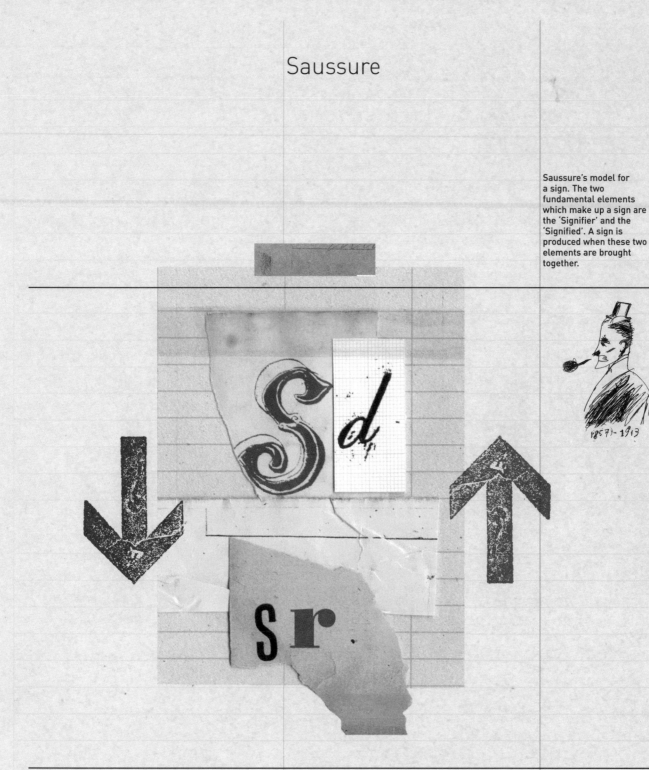

between the components of the sign that enables us to turn signals, in whatever form they appear, into a message which we can understand. Although they used different terminology there are clear parallels between the two descriptions of these models (see diagram p. 24). However, there are also key differences between the studies. The most significant difference is that Saussure's study was exclusively a linguistic study and as a result he showed little interest in the part that the reader plays in the process. This was a major part of Peirce's model as we shall see when we look at **how meaning is formed** in chapter 2. There are three main areas which form what we understand as semiotics; the signs themselves, the way they are organised into systems

31
▼

and the context in which they appear.

The underlying principles which have become the cornerstone of modern semiotics were first heard by students of Saussure in a course in linguistics at the University of Geneva between 1906 and 1911. Saussure died in 1913 without publishing his theories and it was not until 1915 that the work was published by his students as the 'Cours de linguistique generale' (Course in General Linguistics). Prior to this the study of language (linguistics) largely concerned itself with historical usage of languages. In the search for the source of meaning linguists looked to the origins of language. Linguists supposed that if meaning could be found in language then the nature of thought itself could be found by looking at the origins of

There are three main areas which form what we understand as semiotics; the signs themselves, the way they are organised into systems and the context in which they appear.

language. In its early stages linguistics was an attempt to explain signs by imagining them as descriptions of a series of gestures, actions and sensations.

This developed into a comparative study of the forms of words in different languages and their evolution. At this stage linguists were concerned with the structure of language in its own right with no distinct relation to the mind. Prior to his post at Geneva, Saussure himself was concerned with the study of historical languages and had a particular interest in the comparative grammar of Indo European languages particularly Sanskrit.

Saussure was unhappy with the way linguists were approaching language as he felt they had not determined the nature of what they were studying. As a result Saussure proposed an entirely different way of looking at language by returning to the essentials and looking at language as a system of signs. If we could understand how the system of language worked then this may lead us to how meaning is formed. One crucial difference in this approach was that Saussure and the structuralists were concerned with the underlying principles of language which all speakers or bearers of a language have in common. These underlying principles are fixed and do not evolve over time with social or technological change. We will return to this later when we look at **language and speech**.

61
▼
Saussure was a linguist. As a result his theory focused on language and his model is centred on words as signs.

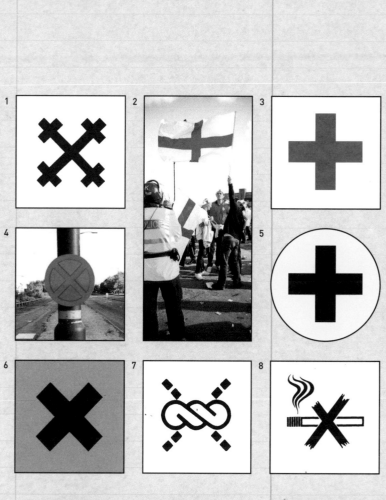

A variety of different crosses. The meaning of each cross is dependent on its context for its meaning.

1. The cross of St Julian
2. The cross of St George
3. The Red Cross
4. No stopping sign (UK)

5. Positive terminal
6. Hazardous chemical
7. Do not wring
8. No smoking

linguistic signs

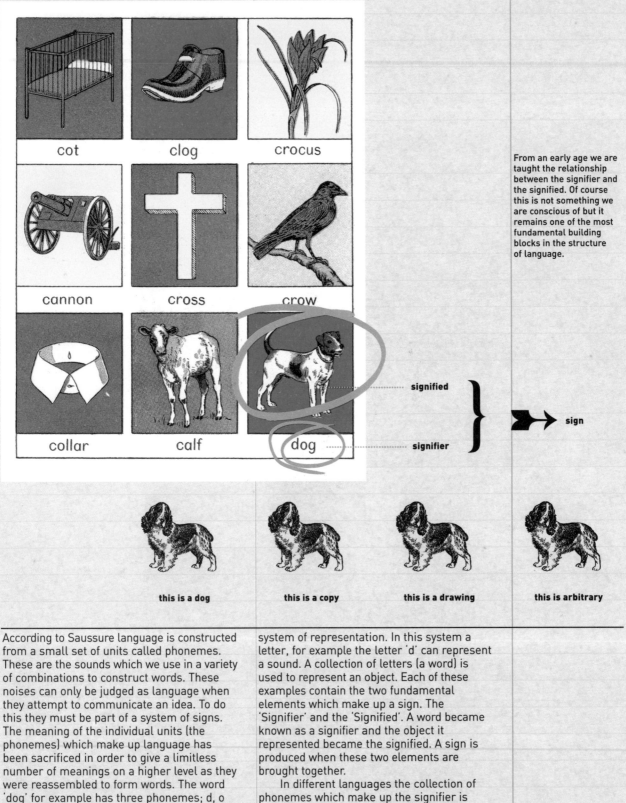

cot clog crocus

cannon cross crow

collar calf dog

signified

signifier

} sign

this is a dog this is a copy this is a drawing this is arbitrary

According to Saussure language is constructed from a small set of units called phonemes. These are the sounds which we use in a variety of combinations to construct words. These noises can only be judged as language when they attempt to communicate an idea. To do this they must be part of a system of signs. The meaning of the individual units (the phonemes) which make up language has been sacrificed in order to give a limitless number of meanings on a higher level as they were reassembled to form words. The word 'dog' for example has three phonemes; d, o and g. In written form the letters d, o and g represent the sounds.

In turn these words then represent objects or more accurately, a mental picture of objects. What Saussure outlined is a system of representation. In this system a letter, for example the letter 'd' can represent a sound. A collection of letters (a word) is used to represent an object. Each of these examples contain the two fundamental elements which make up a sign. The 'Signifier' and the 'Signified'. A word became known as a signifier and the object it represented became the signified. A sign is produced when these two elements are brought together.

In different languages the collection of phonemes which make up the signifier is different. In English speaking countries the object you are now reading from is called a 'book' whereas in French it is 'livre', in Spanish 'libro' and in German it would be 'buch'. What this shows us is that the

duality

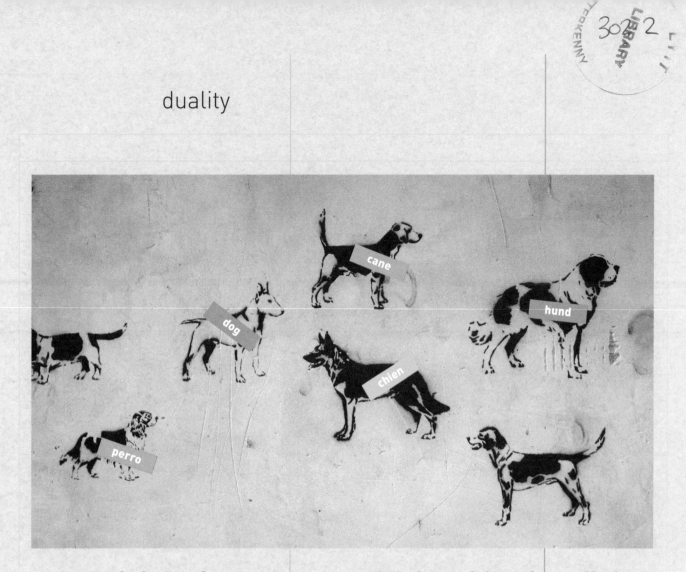

In English speaking countries our four-legged friend is called a 'dog' whereas in France it is 'chien', in Spain 'perro', in Italy 'cane' and in Germany it would be 'hund'. What this shows us is that the relationship between the signifier 'dog' and the thing signified is a completely arbitrary one.

1. **Chaffe W.** *Meaning and the Structure of Language* (1970)

relationship between the signifier 'book' and the thing signified is a completely arbitrary one. Neither the sounds nor their written form bears any relation to the thing itself. With few exceptions any similarity is accidental. Just as the letter 'b' bears no relation to the sound we associate with it then also the word used to describe a book bears no relation to the object it represents. Just as there is nothing book-like in the word 'book', the word 'dog' does not bite, the word 'gun' cannot kill you and the word 'pipe' does not resemble the object used to smoke tobacco. This divorce between meaning and form is called 'duality'.

'Duality freed concept and symbol from each other to the extent that change could now modify one without affecting the other.' [1]

agreement

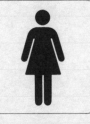 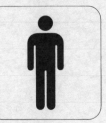

Three versions of signs for man and woman.
Left – runes.
Below – symbols used by the American department of transport.
Right – signs from the font Creation 6 based on the runes. Designed by the author for the Religion issue of 'Fuse' magazine issue no.8.

All that is necessary for any language to exist is an agreement amongst a group of people that one thing will stand for another.

There are two exceptions to this rule but the fact that we can readily identify them as exceptions only reinforces the overriding rule that ordinary signs are constructed from arbitrary relationships. There are of course onomatopoeic words which in some way imitate the things they represent through the sounds they make. A dog for example could be described as a 'bow-wow'. A gun as a 'bang-bang'.

The second exception is where the sequence of sounds which make up the word or the signifier, is constructed from two separate signs which might describe an action or the construction of the object it represents. A 'keyboard' for example describes the object used for typing words. It is quite literally a board which holds the keys. However, this type of second order signifier is only of use in English and does not transfer to other languages. A 'keyboard' in English is 'teclado' in Spanish. So we can see that the relationship between the sound and the thing it represents is learned. It is its use in social practice that helps us to understand its meaning. Saussure also pointed out that

language is not just a set of names that is chosen at random and attached to objects or ideas. We cannot simply replace the arbitrary name for one object in one language for the name in another language. Whereas the English language uses the word 'key' to represent something which we press to type or open a door or play on a piano or a significant idea or moment all from the same signifier, the translation into French would throw up a range of different words. Similarly there are signifiers in one language which have no direct translation into other forms of language. Each language has a series of arbitrary signifiers which exist independently of any other language or dialect. Languages do not just find names for objects and ideas which are already categorised; languages define their own categories.

All that is necessary for any language to exist is an agreement amongst a group of people that one thing will stand for another. Furthermore, these agreements can be made quite independently of agreements in other communities. Saussure proposed that this was true of any language, or dialect.

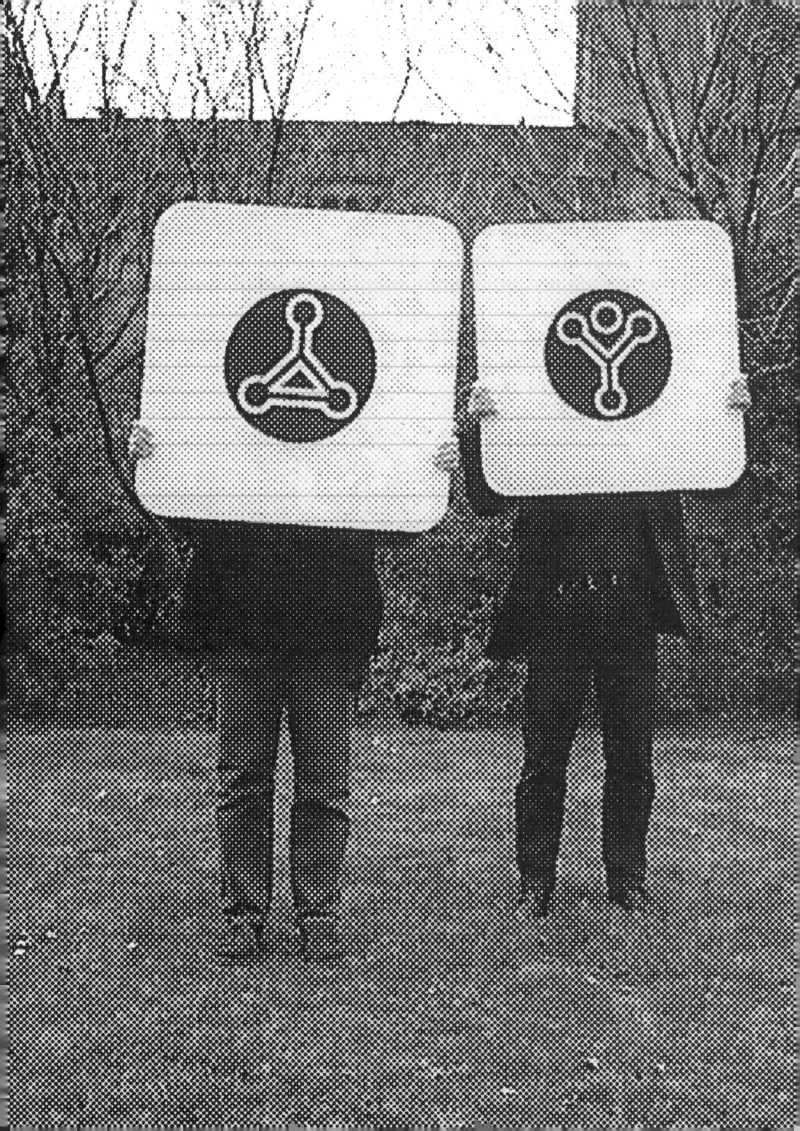

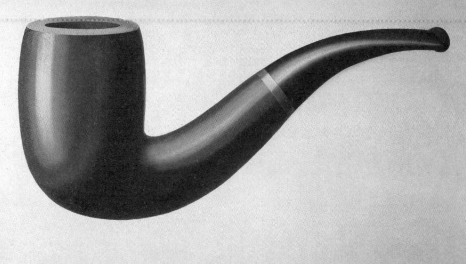

René Magritte
The Betrayal of Images
1929
Los Angeles County Museum of Art C.A., USA/Bridgeman.
©ADAGP, Paris and DACS London 2003

The text beneath the painting is neither true nor false. It is not the physical reality of a pipe, it is a representation of a pipe, a painting of a pipe, a signifier for 'pipe' but not a pipe itself.

This group of people making the agreement became known as a linguistic community. As long as a community remains intact changes in language are likely to be small and everyone can easily adopt or be aware of the changes in meaning. If the community splits then the changes will take different directions with different agreements and eventually the members of one community will have difficulty in understanding the other.

This idea of arbitrary representation based on agreement freed visual artists from a tyranny of words and was explored with much invention in the visual arts. The paintings by the surrealist artist René Magritte in his series entitled 'The Key of Dreams' (1930) show a collection of objects arranged in a grid. Each one is labelled as in a child's picture book. However, in this case three of the images are incorrectly labelled whilst the fourth image is labelled correctly. In 'The Betrayal of Images' (1929) Magritte labels an image of a pipe with the phrase 'This is not a pipe'. Both these paintings highlight the arbitrary nature of language and invite the viewer to rediscover the ordinary. The text beneath the painting is neither true nor false. For artists this presented the opportunity to make poetic associations between signifiers and the signified. Wittgenstein, a philosopher and contemporary of Magritte's wrote that:

> *'the aspects of things that are most important for us are hidden because of their simplicity and familiarity.'* [2]

In a later example the pop artist Marcel

2. Wittgenstein L. *Philosophical Investigations* (1963) in Gablik S. *Magritte* (1970)

ENSEIGNEMENT AGRICOLE

LES ANIMAUX DE LA FERME

CHEVROLET

CADILLAC

CHRYSLER

MASERATI

FIAT

JEEP

LAND ROVER

AUSTIN

ROLLS ROYCE

MERCEDES

VOLKSWAGEN

BMW

CITROEN 2 CV

SIMCA

RENAULT 4 L

Neudruck von Marcel Broodthaers

Marcel Broodthaers
The Farm Animals
1974
©Tate London 2003,
DACS London 2003

Peirce

On the left Saussure's model for a sign and on the right the version proposed by Peirce. As we can see the two models are remarkably similar despite the difference in terminology.

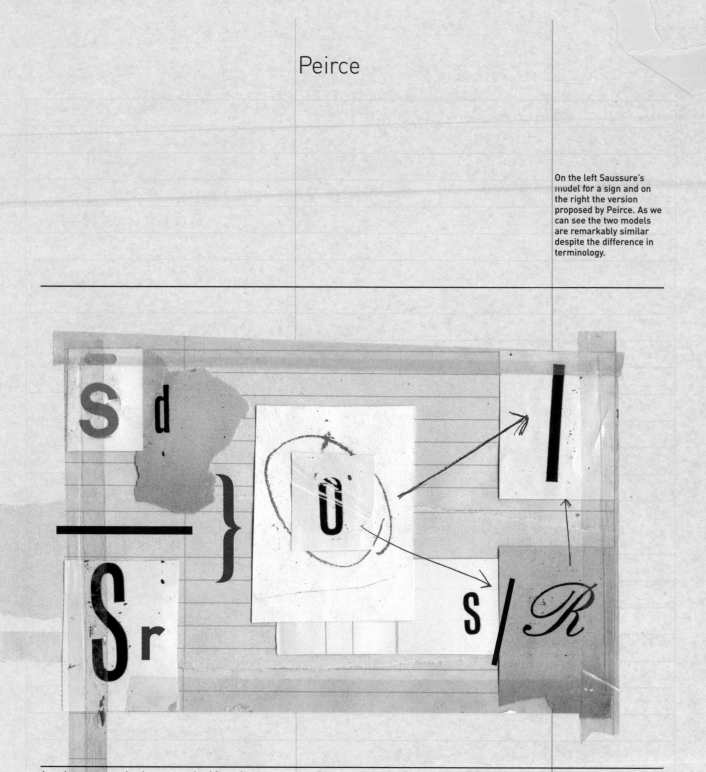

In a later example the pop artist Marcel Broodthaers uses the same principle to label a series of animals with the names of automobile manufacturers in 'The Farm Animals' (1974). In this case the viewer makes new signs in their mind's eye by searching for an association between the images taken from nature and the names from international manufacturing.

Charles Sanders Peirce is the philosopher who is recognised as the founder of the American tradition of semiotics. Whereas Saussure was primarily interested in language, Peirce was more interested in how we make sense of the world around us. Peirce's model for the sign was triangular and deals with the sign itself, the user of the sign and the external reality – the object (O) referred to by the sign.

In this model, the sign (sometimes referred to as the representamen S/R) is very similar to Saussure's signifier (Sr). This is the physical evidence of the sign. This can be for example a word, a photograph, a painting or a sound. Saussure's signified (Sd) becomes the interpretant (I) in Peirce's model. This is not merely the user of the sign but a mental

3. **Zeman J.** *Peirce's Theory of Signs* (1977) in **Sebeok T.** *A Profusion of Signs* (1977)

'A sign is something which stands to somebody for something in some respect or capacity. It addresses somebody, that is, creates in the mind of that person an equivalent sign, or perhaps a more developed sign. The sign which it creates I call the interpretant of the first sign. The sign stands for something, its object.' [3]

concept of the sign which is based on the user's cultural experience of the sign. The interpretant is not fixed. It does not have a single definable meaning, but its meaning can vary depending on the reader of the sign. The emotional response to the word 'book' will vary depending on the reader's experience of books. For some it may be a comforting and affectionate response based on a lifetime of reading and escape through literature, where for others it may be a suspicious and defensive response based on the book as an instrument of official institutions.

David Crow
Museum in Progress
agreement

The Museum in Progress project was an exhibition which took place entirely in the media. This example shows the work made for a full-page invitation in the Austrian daily newspaper 'Der Standard'. This was an opportunity to test whether a series of seemingly abstract marks created in the UK could be read by the public in Austria. The marks were labelled with adjectives by their creators and the Austrian audience were asked to match the adjectives to the abstract graphic shapes.

	4	⟳	⊛	ℛ
relaxing	0	64	28	16
exciting	72	4	4	20
fresh	28	12	8	48
calm	16	20	60	16

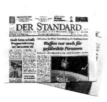

Top – The percentage response for each adjective (the correct adjective is highlighted in red).
Above – The process of making the marks. The creators make the paths and anchor points by placing stones on a grid.
Right – A selection of the marks returned by the audience in Austria.

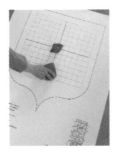 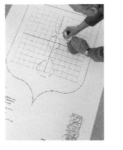 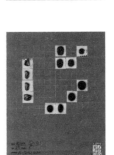

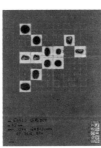 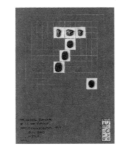 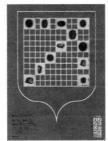

Paul Davis
Survival Pants
linguistic signs

The notion of 'danger' is introduced to the fleeing survival pants using only a linguistic sign. The arrow tells us that the danger is hidden but is about to arrive in the frame. The word 'danger' also fixes our interpretation of the running legs.
It is this linguistic sign which changes the reading from just 'running' to 'fleeing' *(see also anchorage in Text and Image – chapter 4).*

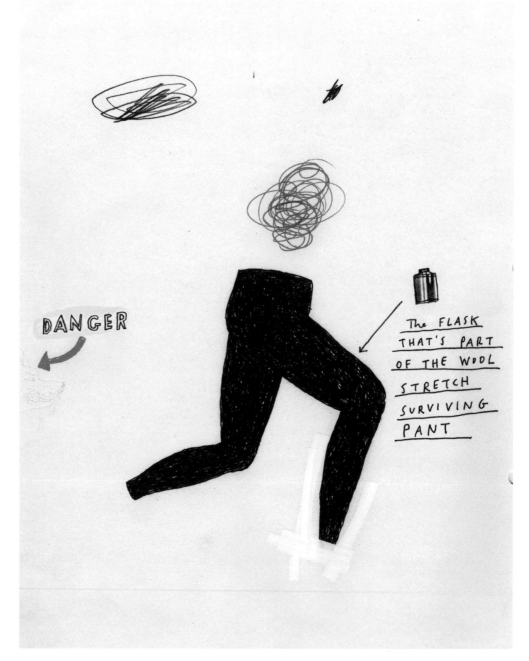

DANGER

The FLASK THAT'S PART OF THE WOOL STRETCH SURVIVING PANT

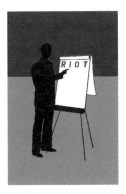

Lawrence Zeegan
Office Politics
linguistic signs

The silhouetted figure is labelled with a linguistic sign as is the flip chart which he is using to present his ideas. As a result the seemingly harmless figure takes on an altogether more sinister appearance. The banal clip-art aesthetic is undermined and a hidden agenda appears *(see also anchorage in Text and Image – chapter 4)*.

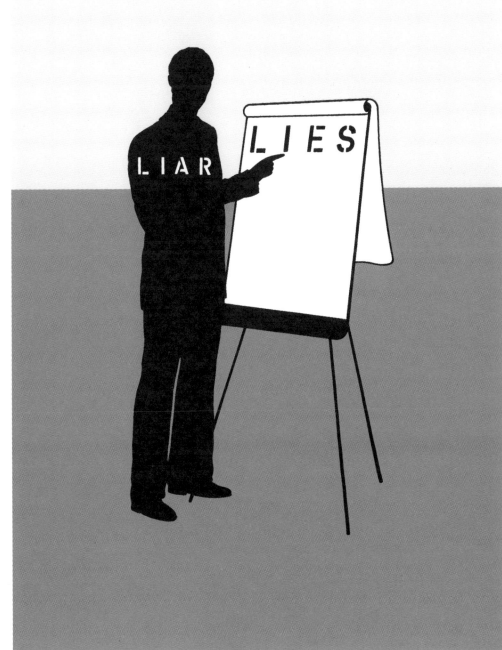

how meaning is formed

2

2. how meaning is formed

'In a language state everything is based on relations.' [1]

This chapter looks at the various ways in which meaning is formed in a sign. Both Saussure and Peirce agreed that in order to understand how we extract meaning from a sign we need to understand the structure of signs. To help us do this they categorised signs in terms of the relationships within the structures.

1. de Saussure F. *Course in General Linguistics* (1974) (1st edition 1915)

categories

Peirce defined three categories of signs;

Icon – this resembles the sign. A photograph of someone could be described as an iconic sign in that it resembles physically the thing that it represents. It is also possible to have iconic words where the sound resembles the thing it represents. Onomatopoeic words like 'bang' or 'woof' could be described as iconic language.

Index – there is a direct link between the sign and the object. In this category smoke is an index of fire and a tail is an index of a dog. Traffic signs in the street are index signs as they have a direct link to the physical reality of where they are placed such as at a junction or at the brow of a hill.

Symbol – these signs have no logical connection between the sign and what it means. They rely exclusively on the reader having learnt the connection between the sign and its meaning. The red cross is a symbol which we recognise to mean 'aid'. Flags are symbols which represent territories or organisations. The letters of the alphabet are symbolic signs whose meaning we have learnt.

As a linguist Saussure was not interested in index signs, he was primarily concerned with words. Words are symbolic signs. In the case of onomatopoeic words they can also be iconic signs. Saussure categorised signs in two ways which are very similar to the categories used by Peirce;

Iconic – these are the same as Peirce's icons, they resemble the thing they represent.

Arbitrary – these are the same as Peirce's symbols. The relationship between the signifier and the signified is arbitrary. It functions through agreed rules.

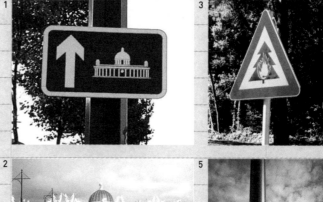

1 and 2 – This shopping centre in Manchester is signposted using an iconic sign. In this example the sign depends on local knowledge.

3 – An index/symbol. The danger of fire is linked to the forest through its physical position (the sign is on the edge of the forest) and by the use of an ideogram of a tree.

4 and 5 – The Red Cross and the letters of an alphabet are all symbols. The meaning of these signs relies on the reader having learnt the correct codings in advance.

categories

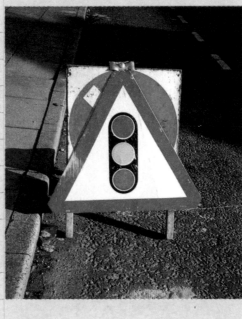

It is important to recognise that whichever terms you use, the categories are not separate and can function together in sets. For example let's look at the traffic sign which warns us that we are approaching traffic lights. The mark on the sign which resembles the lights is both an icon and a symbol. As it looks physically like the thing it represents it could be said to be iconic. However, it is also a symbol. That is to say it is part of a set of signs for which we have international agreement about their meaning. We have learnt what the signs mean. We may even have been tested on their meaning as part of a driving test before we can take our car on the road. The red triangular frame around the sign is a symbol which we understand as a warning sign. Furthermore, when this traffic sign is placed in the street next to the road junction it also becomes an index sign. In reality its meaning is in part formed by where the sign is placed. It is an icon/symbol/index sign.

Firstness – **A sense of something**
Secondness – **This is the level of fact**
Thirdness – **You could think of this level as the mental level**

Peirce also identified three levels or properties for signs which can be mapped on to his triangular model. He labelled these properties firstness, secondness and thirdness.

Firstness – This is a sense of something. It could be described as a feeling or a mood. To say that you are feeling 'blue' could be said to function on this first level.

Secondness – This is the level of fact. The physical relation of one thing to another. The traffic sign we discussed earlier functions on this physical level of fact.

Thirdness – You could think of this level as the mental level. It is the level of general rules which bring the other two together in a relationship. It relates the sign to the object as a convention. The association we have in our minds between the 'Stars and Stripes' and the United States is a mental relationship which relies on a convention.

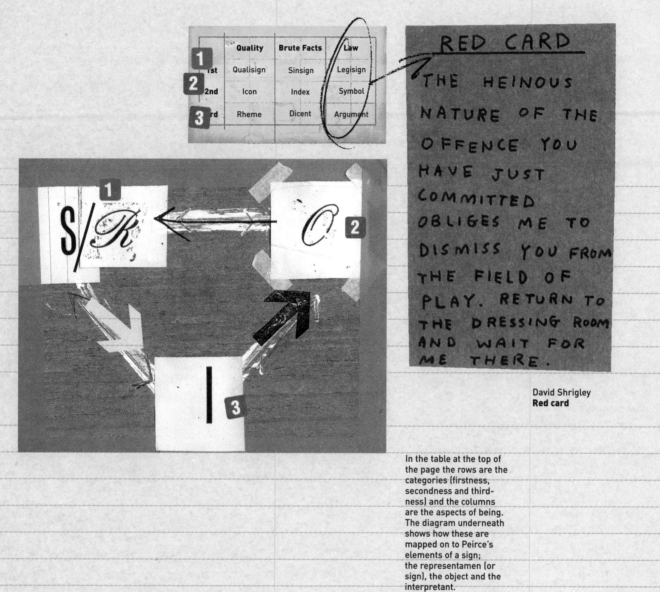

	Quality	Brute Facts	Law
1st	Qualisign	Sinsign	Legisign
2nd	Icon	Index	Symbol
3rd	Rheme	Dicent	Argument

RED CARD

THE HEINOUS NATURE OF THE OFFENCE YOU HAVE JUST COMMITTED OBLIGES ME TO DISMISS YOU FROM THE FIELD OF PLAY. RETURN TO THE DRESSING ROOM AND WAIT FOR ME THERE.

David Shrigley
Red card

In the table at the top of the page the rows are the categories (firstness, secondness and third-ness) and the columns are the aspects of being. The diagram underneath shows how these are mapped on to Peirce's elements of a sign; the representamen (or sign), the object and the interpretant.

The meaning which we get from a sign can function on more than one level at the same time. For example, a white flag which signifies 'surrender' or a red card which is used to dismiss a player from the field of play is an argument (a reason), it is symbolic (its meaning is learnt through convention) and it is a legisign (it is made up of a law). A dicent/indexical/sinsign is exactly the same as an argument/symbol/legisign.

Semiosis

Peirce uses the term 'semiosis' to describe the transfer of meaning; the act of signifying. What is distinct about his view of semiosis is that it is not a one-way process with a fixed meaning. It is part of an active process between the sign and the reader of the sign. It is an exchange between the two which involves some negotiation. The meaning of the sign will be affected by the background of the reader. Their background, education, culture and their experience will all have a bearing on how the sign is read. One of the most visible examples of this is the symbolic use of colour in different cultures. In Western Europe we are familiar with the colour black as a symbol of death and mourning. When we attend funerals we wear a black tie. The funeral directors wear black jackets and it is usual for those who attend to wear black. Sportsmen wear black armbands to show respect for those who have been lost. This is a symbolic sign which we have all learned and also to a degree it is iconic. However, in other cultures across the world this relationship between colour and loss is quite different. In China for example white is used for funerals, a complete reversal of the values which could give the appearance of a wedding to a Western European who is used to a quite different understanding of the symbolic use of white.

Unlimited Semiosis

In the previous chapter we looked at the terms used by Peirce in his triangular model of a sign. The 'representamen' which represents an 'object' which in turn conjures up a mental concept, the 'interpretant', in **24** the mind of the reader. However, when ▼ we consider meaning we must recognise that this triangular process may happen more than once from one starting point. To use Peirce's terms, the interpretant resulting in our mind from the first representamen can then become a further sign and trigger an infinite chain of associations where the interpretant in one sequence becomes the representamen of the next sequence. This is best understood as a diagram (see opposite). This phenomena called 'unlimited semiosis' is commonplace in our reading of signs and we will rush through these chains of meanings at such speed that we hardly notice the chain at all. This is similar to Barthes' Structure of Myths which is based on Saussure's model of the sign.

The triangular process described by Peirce may happen more than once from one starting point. The 'interpretant' resulting in our mind from the first 'representamen' can then become a further sign and trigger an infinite chain of associations where the interpretant in one sequence becomes the representamen of the next sequence.

Value

For Saussure it was what he called 'value' that determined the meaning of a sign. Saussure focused on the relationship between the sign and the other signs in the same system. He looked at what we mean by something in relation to what we do not mean by something. In his system, 'book' means not magazine, not poster, not film. Saussure has a different term for the transfer of meaning. He calls this 'signification'. For Saussure signification is achieved by using the mental concepts, the signifieds, to categorise reality so that we can understand it. The signified are artificial things which are made by us and our society and culture. They are a part of our communication system which is unique to our particular culture. The meaning comes not from the relationship of this sign to reality, it can be arbitrary as he has pointed out, but from the relationship between the sign and the other signs around it. To illustrate this Saussure describes language as a sheet of paper with thought on one side and sound on the other. We cannot cut the front of the sheet without cutting the back at the same time. Sound and thought cannot be divided.

'Language is a system of interdependent terms in which the value of each term results solely from the simultaneous presence of the others.' [2]

If we cut the sheet of paper into three pieces the meaning of each piece does not come from the relationship between the front and back of the paper but from the relationship of one piece to another.

2. de Saussure F. *Course in General Linguistics* (1974) (1st edition 1915)

sound

sound

sound

sound

thought

thought

thought

value

syntagm

The value is always composed of 2 things; 1. a dissimilar thing which can be exchanged. 2. a similar thing which can be compared.

'The idea or phonic substance that a sign contains is of less importance than the other signs around it.

Proof of this is that the value of a term may be modified without either its meaning or its sound being affected, solely because a neighbouring term has been modified.' [3]

This is essentially a theory of combination and substitution which Saussure explains using the terms syntagm and paradigm.

Syntagm

This is a collection of signs which are organised in a linear sequence. The word 'book' is a syntagm using a set of units – b/o/o/k. A sentence is also a syntagm. If we take the sentence, 'The girl reads the book', the words are the signs which are arranged into a syntagmic sequence where each sign has a syntagmic relation to the signs which go before it and after it. As with the word 'book', the value of these signs is affected by the other signs around them.

In visual terms the clothes we wear are a syntagm made up of units which are the individual garments. The garments themselves are also syntagms where each garment is made of units such as sleeves, collars, cuffs etc. As with the previous examples the value of these units (signs) can be affected by their combination with the other signs. We all create syntagms every day where the combinations are governed by conventions. These conventions or rules are a feature of the syntagm. When we are writing we call this convention 'grammar', when we are dressing ourselves for the day we might call it 'taste'.

3. de Saussure F. *Course in General Linguistics* (1974) (1st edition 1915)

David Crow
Creation 6

Sketches from the
development work for the
Creation 6 font displayed
on page 47.
Each subset within the
font is a paradigm in
itself. The symbols circled
are all part of a paradigm
of found images which in
this instance represent
various 'events'.

The two basic characteristics of a paradigm are that; 1. the units in the set have something in common. 2. each unit is obviously different from the others in the set.

Paradigm

The meaning we get from a collection of signs (signification) does not come from these linear combinations alone. When we are making combinations of signs whether they are words, sentences or outfits we are faced with a series of individual choices where we can substitute one sign for another in the same set. If we take the letters of the alphabet as a simple example. These are all part of a paradigm which we recognise as part of the same set. 'A' is part of the paradigm that is the alphabet where '5' is not and '+' is not. When we make choices from this paradigm we create words which are part of another set of paradigms – nouns, verbs etc. If we substitute an 'n' for an 'o' from the alphabet paradigm in the syntagm 'b-o-o-k' to form 'b-o-n-k' we change the meaning entirely. The way that we use language creates another set of paradigms such as legal jargon, technobabble and bad language. When writing poetry we could describe the rhyming words as paradigms which are based on sound.

In typography we could say that FF Din Regular is part of a paradigm that includes the entire set of weights that make up the FF Din family and in turn this family of typefaces is part of the paradigm of sans-serifs. The way we fix one part of a garment to the other is a choice made from a set of possibilities which form a tailoring paradigm. The way we choose to apply colour to a painting is part of another paradigm. In video the way we edit

FF Din light
FF Din regular
FF Din medium
FF Din bold
FF Din black

from one sequence to another is a choice made from a paradigmical set of conventions where the fade, the dissolve, the cut all have meanings of their own. In music it may be the way we arrange sounds together to form melody. Our choice of car and the choices we make to decorate our homes with objects are made from a set of paradigms.

Codes

As we can see from these examples some of the paradigms have a fixed number of units to choose from; the alphabet, the number of weights in a family of typefaces etc.

These types of paradigms are made of codes which are called 'digital codes'. These types of codes are easy to recognise and understand as the units are clearly defined.

There are also paradigms on the list above which do not have a fixed number of choices but instead the range of choice is unlimited and the divisions between the choices are unclear. The marks produced by a paintbrush or the sounds used in music could be described as paradigms which use codes with no clear distinction between the choices. This type of code is called an 'analogue code'. In practice it is common for us to attempt to impose digital notation on to analogue codes to help us categorise and understand the codes. Musical notation for example is an attempt to do just this.

metaphor & metonym

David Crow
Nervous Robot

Sketches from the
development work for
the print displayed on
page 51.

Above – The dark cloud is
used as a *metaphor* for
bad news. By placing the
image of a political figure
inside the cloud the bad
news is associated with
that figure. The *value* of
the sign has been formed
by its relationship with
the other signs around it.

Above – The characteris-
tics of a butterfly in flight
are used as a *metaphor*
for feeling nervous by
simply placing the image
in the stomach of the
robot.

Metaphor & Metonym

In terms of the practical application of
paradigmical choice it may be easier to
understand using the terms metaphor and
metonym [4]. Where we substitute one word or
image in a sequence for another we can
transfer the characteristics of one object to
another. This use of metaphor is very common
in advertisements where a product is imbued
with particular properties it is not readily
associated with (see example). We can also
apply this type of metaphoric substitution to
other forms of media. Were you to remove the
sleeves from a Saville Row pinstripe suit and
refasten the sleeves using safety pins, this
paradigmical choice would change the way
we read the suit entirely. We would naturally
make assumptions about the individual
wearing the suit based on this change. The
pins are part of a paradigm of fasteners.
That they are not normally used as the
conventional way of fastening a well-tailored
suit can be used to change the meaning of
the suit. The irreverence and immediacy of
the pins is transferred to the suit and would
become part of our overall reading of the
garment and the statement that it makes.

A metonym works in a similar way except
that it is used to represent a totality. Where
we want to signify reality in some way then
we are forced to choose one piece of that
reality to represent it. For example, if we want
to represent all children we might use an
image of a child. In this case the image of one

4. Jakobson R. and Halle
M. *The Fundamentals of
Language* (1956)

The important thing to remember is that where there is choice, there is meaning.

child is being used as a metonym to represent the whole, all children.

With all these paradigmical choices the meaning comes largely from the things we did not choose. There is not necessarily any fixed number of options in a paradigm and each individual is likely to generate a different range of choices. It is also possible for the collection of signs in any given paradigm to change over time, where meanings of words, images and gestures change through the natural evolution of social change. The important thing to remember is that where there is choice, there is meaning.

David Crow
Creation 6
paradigm

David Crow
Lineage
value

Font for 'Fuse' magazine
Religion issue No. 8.
The font holds a basic set
of symbols which can be
used to describe a
creation myth. A number
of subsets such as events,
human relationships and
deities exist within the
font. Each subset is a
paradigm in itself.
For example, events are
found images, human
relationships are based
on runes, deities on
engineering diagrams and
so on. Symbols can also
be combined to form
signs with added detail.

The characters shown are;
In The Beginning...,
The Lord,
The Sun,
The Magician,
Daughter of...,
The Birds,
Middle Aged Family Man
of Ill Health,
Festival.

Characters from the
Creation 6 font are
placed into a sequence
of photographs which
describe a section of
family histories. The
meaning of each charac-
ter can then be deduced
from the relationship
between the symbols
and the photographs.

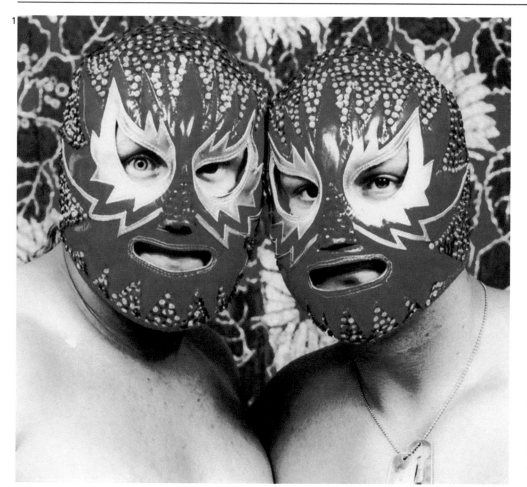

Stylorouge
Perverse

A series of photographs for a 'Jesus Jones' album showing the way that the value of a sign is affected by the presence of other signs around it.

Frame 1
In the first frame we are presented with a close-up of a team of two masked wrestlers. The crop encourages us to focus on the emotions in the image. We could read *power, strength, heat, aggression* and so on. The identity tags suggest military dog tags.

Art Direction
Stylorouge
Photography
Takashi Homma

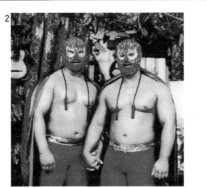

2

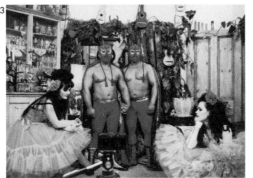

Frames 2, 3, 4, 5

The camera pulls back to reveal that the wrestlers are holding hands. This immediately changes the emotive nature of the image. We now sense there is a reason why one wrestler wore both identity tags. The context is gradually revealed.

The mysterious kitsch setting becomes a photographic studio. We see that the wrestlers are only part of a composition which includes what appears to be two other models. Finally we see the window frame and the Victorian brick wall and discover that the entire scene is taking place in what could be a suburban home. What appeared at first to hold a sense of danger and glamour has gradually eroded until our final impression which is bound up in notions of eccentricity and fetish.

3

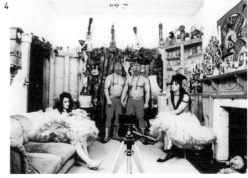

4

5

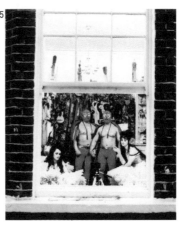

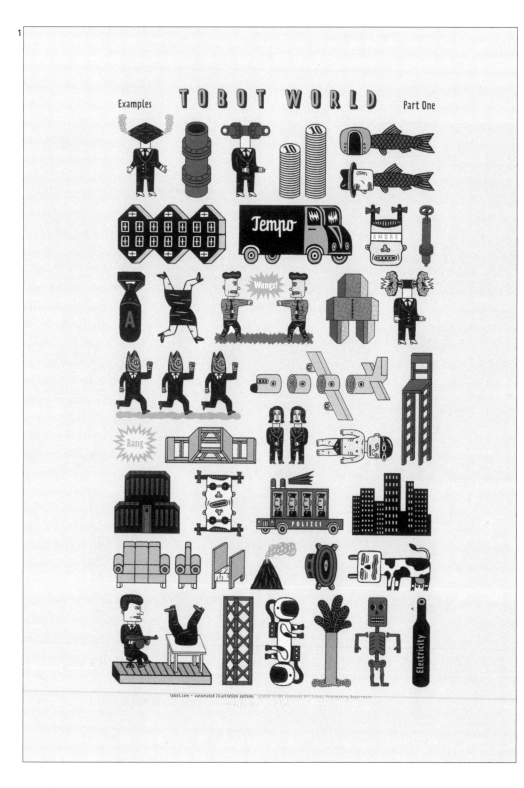

1

1. Henning Wagenbreth
Tobot World
paradigm

Tobot is an automated illustration system designed to be accessed from the keyboard. Tobot works in a font format and is created using font authoring software in a similar way to a typeface. Like an alphabet it can also be thought of as a paradigm and contains the two basic characteristics of a paradigm;
1. the units in the set have something in common.
2. each unit is obviously different from the others in the set.
The screen print displays a collection of characters from Tobot combined in a number of different ways showing the versatility of this particular paradigm. Each character has a number of layers which can be used to colour the illustration as in the example shown here.

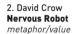

2. David Crow
Nervous Robot
metaphor/value

The dark cloud is used as a *metaphor* for bad news. By placing the image of a political figure inside the cloud the bad news is associated with that figure. The *value* of the sign has been formed by its relationship with the other signs around it. The characteristics of a butterfly in flight are used as a *metaphor* for feeling nervous by simply placing the image in the stomach of the robot.

3. Alan Murphy
Original Heroes of Kirkdale
syntagm

The screen print is part of a set of prints all titled 'Original Heroes of Kirkdale'. Each print is part of a syntagm, a collection of signs which is organised in a linear sequence. The order of this particular syntagm is determined by the inclusion of part of the place name 'Kirkdale' on each print.

4. Jonathan Hitchen
Geeks
paradigm

This example of a paradigm is made using bespoke software called 'image bin' which generates random overlays from a collection of related bitmap drawings.

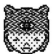

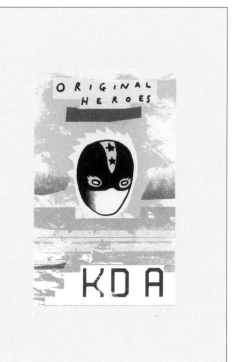

KIR KDA LE

reading the sign

The meaning of any sign is affected by who is reading that sign. Peirce recognised a creative process of exchange between the sign and the reader.

Although we can see many similarities between Peirce's 'interpretant' and Saussure's 'signified' it is clear that Saussure wasn't concerned with the relationship between the signified and the reality which it refers to. The reality that Peirce calls the 'object' does not feature at all in Saussure's model. Saussure was concerned only with language and he does not discuss the part played by the reader. His theories concentrated instead on the complex structures of language which we use to construct words and sentences.

'A science that studies the life of signs within society is conceivable; it would be part of social psychology and consequently of general psychology; I shall call it semiology (from Greek semeion "sign"). Semiology would show what constitutes signs, what laws govern them. Since it does not yet exist, no one can say what it would be; but it has a right to existence, a place is staked out in advance. Linguistics is only a part of the general science of semiology; the laws discovered by semiology will be applicable to linguistics, and the latter will circumscribe a well-defined area within the mass of anthropological facts.' [1]

However the meaning of words can change depending on who reads them. In the USA Peirce had created a theory which saw the reading of signs as part of a creative process.

1. de Saussure F. *Course in General Linguistics* (1974) (1st edition 1915)

Whereas Saussure saw linguistics as forming one part of semiology, Barthes turned this idea upside down and suggested in fact that semiology, the science of signs, was in fact one part of linguistics.

In Europe it was Roland Barthes a follower of Saussure's who took the theoretical debate forward. In the 1960s Barthes developed Saussure's ideas so that we could consider the part played by the reader in the exchange between themselves and the content.

For Barthes the science of signs takes in much more than the construction of words and their representations. Semiology takes in any system of signs whatever the content or limits of the system. Images, sounds, gestures and objects are all part of systems which have semiotic meanings. In the 1960s, Barthes described complex associations of signs which form entertainment, ritual and social conventions. These may not normally be described as language systems but they are certainly systems of signification.

Whereas Saussure saw linguistics as forming one part of semiology, Barthes turned this idea upside down and suggested in fact that semiology, the science of signs, was in fact one part of linguistics. He sees semiology as;

'...the part covering the great signifying unities of discourse.' [2]

Barthes saw that there was a significant role to be played by the reader in the process of reading meaning. To do this he applies linguistic concepts to other visual media which carry meaning. Like Saussure and Peirce before him Barthes identified structural relationships in the components of a sign. His ideas centre on two different levels of signification; denotation and connotation.

2. **Barthes R.** *Elements of Semiology* (1968)

denotation connotation

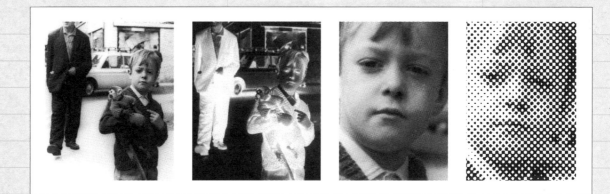

Denotation – what is pictured

This first order of signification is straightforward. It refers to the physical reality of the object which is signified. In other words a photograph of a child represents a child. No matter who photographs the child and how they are photographed, in this first order of signification, they still just represent 'child'. Even with a range of very different photographs the meanings are identical at the denotative level.

Connotation – how it is pictured

In reality we know that the use of different film, different lighting, framing, soft focus etc. all change the way in which we read the image of the child. A grainy black-and-white or sepia-toned image of a child could well bring with it ideas of nostalgia, a soft focus might add sentiment to the reading of the image and a close-up crop of the face will encourage us to concentrate on the emotions being experienced by the child. All these differences are happening on the second level of signification which Barthes called connotation.

The reader is playing a part in this process by applying their knowledge of the systematic coding of the image. In doing this the meaning is affected by the background of the viewer. Like Peirce's model this humanises the entire process.

Connotation is arbitrary in that the meanings brought to the image at this stage are based on rules or conventions which the reader has learnt. The consistent use of soft focus for example in film and advertising has found its way into our consciousness to a degree that it is universally read as sentimental or soft-hearted. As the conventions vary from one culture to another then it follows that the connotative effect of the conventions, the rules on how to read these images will also vary between communities.

A black-and-white photograph can be read as nostalgic. A negative could be a reference to the process of photography or to forensics and crime. This is helped by the mysterious crop of the man in the background. A close-up draws our attention to the emotional aspects of the subject and the coarse dot reproduction suggests low-quality printing and can in turn suggest either newspaper journalism or political campaigns.

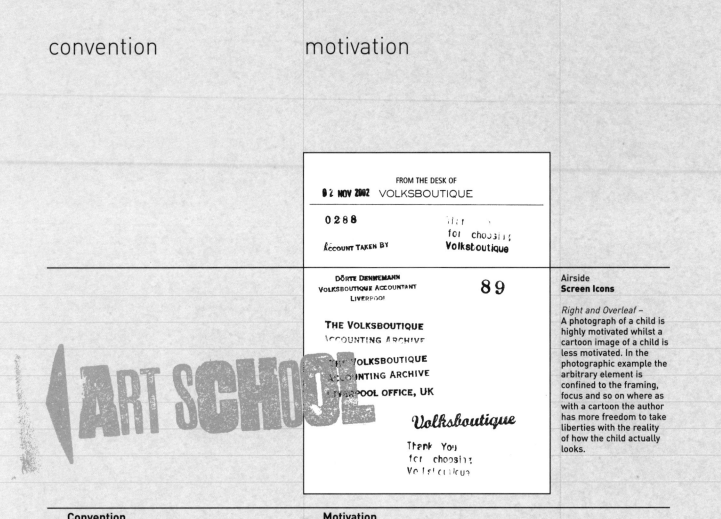

FROM THE DESK OF

0 2 NOV 2002 VOLKSBOUTIQUE

0 2 8 8

ACCOUNT TAKEN BY

DÖRTE DENNEMANN
VOLKSBOUTIQUE ACCOUNTANT
LIVERPOOL

THE VOLKSBOUTIQUE
ACCOUNTING ARCHIVE

THE VOLKSBOUTIQUE
ACCOUNTING ARCHIVE
LIVERPOOL OFFICE, UK

Volksboutique

Thank You
for choosing
Volksboutique

for choosing
Volksboutique

89

Airside
Screen Icons

Right and Overleaf –
A photograph of a child is highly motivated whilst a cartoon image of a child is less motivated. In the photographic example the arbitrary element is confined to the framing, focus and so on where as with a cartoon the author has more freedom to take liberties with the reality of how the child actually looks.

Convention

This is an agreement about how we should respond to a sign. We have already mentioned conventions such as the close up and the high-grain black-and-white image. Conventions such as these pepper all the images we read today. We instinctively know that slow motion footage does not mean that the action is happening very slowly. We understand that we are supposed to use this as a signal to study the skill of the action or admire its beauty. The roughly rendered typography of the rubber stamp gives it a gestural immediacy. It suggests the informal. We can almost sense the sound that the stamp would make when the image was made. So much of the meaning comes from convention that signs with little convention need to be very iconic in order to communicate to a wide audience. Another way of describing this is to say that a sign with little convention needs to be highly motivated.

Motivation

This term is used to denote how much the signifier describes the signified. For example, a photograph is a highly motivated sign as it describes in detail the subject in the image. It looks like the thing or the person it represents. Using the term provided by Saussure and Peirce it is 'iconic'. A highly motivated sign is a very iconic one. Using the complimentary terms, an arbitrary sign (Saussure) or if you prefer a symbolic sign (Peirce) could be described as unmotivated. Using the example we used earlier, a photograph of a child is highly motivated whilst a cartoon image of a child is less motivated. In the photographic example the arbitrary element is confined to the framing, focus and so on where as with a cartoon the author has more freedom to take liberties with the reality of how the child actually looks. However, the less the sign is motivated the more important it is that the reader has learnt the conventions which help us to decode the image.

boy

boy in a bear suit

boy with big hair

monkey

girl

girl with flower in hair

princess

panda

language and speech

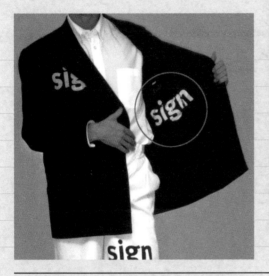

In the 'garment system' the language is the parts of the garment and the rules which govern their association. Speech in the 'garment system' would then be the individual way of wearing, the personal quirks, the degree of cleanliness, size, the free association of the pieces and so on.

It is important that the author of the unmotivated sign can be sure that the readers have learnt the conventions in advance or the meaning may be lost.

Language and Speech

We could think of these differences between the first and second order of signification as the differences between what we say and the way we say it. (Saussure distinguished between the two which he called 'Langue' and 'Parole'. However, as we have seen Saussure's primary concern was the system, the language, 'La Langue'.) Language, says Barthes, is language minus speech and at the same time it is a social institution and a system of values. Speech according to Barthes is an individual act of selection and actualisation. By way of distinguishing language from speech Barthes [3] gives us examples through introducing the idea of 'systems' of language and speech. In what he calls the 'garment system' Barthes describes the language as the parts of the garment along with the rules which govern the association of the parts. Speech in the 'garment system' would then be the individual way of wearing, the personal quirks, the degree of cleanliness, size, the free association of the pieces and so on. With the 'car system' the variations in the way we drive would then make up the plane of speech. This correlates closely with Willis' [4]

3. Barthes R. *Elements of Semiology* (1968)

4. Willis P. *Common Culture* (1990)

myth

Seel Garside
Ladies Night

Angelina, Buffy,
Catherine, Demi,
Elizabeth, Fiona,
Gwyneth, Helena,
Isabella, Julia, Katie,
Laura, Mia, Nicole, Olivia,
Patricia, Queenie, Rachel,
Sandra, Theresa, Uma,
Victoria, Winona, Xena,
Yoko, Zoe

ideas about 'symbolic creativity', which relate exactly to these types of everyday expression. So then we can say that when people adopt different hairstyles, for example, although they are using the same language (the hairstyle system perhaps) they are using different forms of speech, speaking differently, or to use Bourdieu's terminology [5], they are using different dialects. Using the example of the rubber stamp, the words are the language and the qualities of the stamp is the speech. This idea of using a tone of voice is very useful to those of us who use typography as a communication tool.

Myth

Barthes [6] saw a new approach to semiotics which would force us to look more closely at what we take for granted in our visual culture. In his essays on myths in contemporary culture he draws attention to a range of misconceptions in French society about the properties and meanings we attach to images of the things around us. The 'purity' of washing powder, the 'sport' of wrestling, the 'Frenchness' of wine. Barthes was angered by the way contemporary society confused history for nature.

For him myths were the result of meaning being generated by the groups in our society who have control of the language and the media. These meanings are seen as part of the natural order of things. Where these meanings came from and the process which transformed the meaning of the signs are either forgotten or hidden. This process of generating myths filters the political content out of signification. In today's society the modern myths are built around things like notions of masculinity and femininity, the signs of success and failure, what signifies good health and what does not.

5. **Bourdieu P.** *Language and Symbolic Power* (1991)

6. **Barthes R.** *Mythologies* (1973)

In today's society the modern myths are built around things like notions of masculinity and femininity, the signs of success and failure, what signifies good health and what does not.

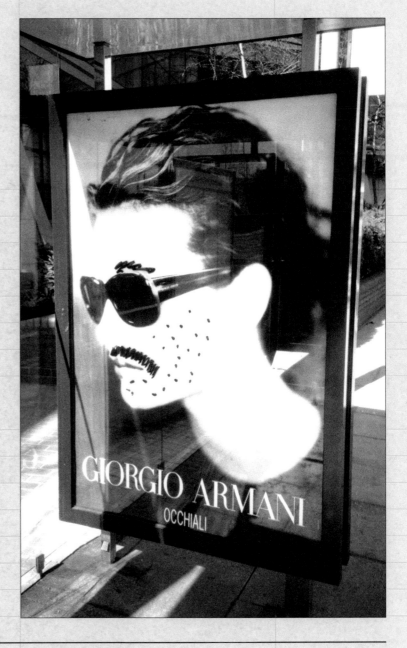

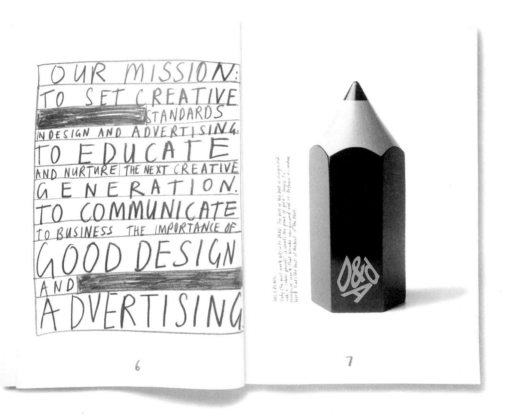

Marion Deuchars
**British Design & Art
Direction
Review/Summary
Accounts**
connotation

The D&AD mission
statement is given an
informal tone of voice by
Marion Deuchars. On the
denotative level it is clearly
a mission statement but
on the connotative level it
speaks in the tone of
voice of the creative
designer. The pencil
drawing suggests the
process of thinking and
also relates directly to the
D&AD yellow pencil
trademark.

Illustrator
Marion Deuchars
Design Consultancy
Frost Design
Copywriter
Howard Fletcher

David Crow & Yaki Molcho
Dialogue
language and speech

Dialogue is a dual alphabet font which features both the Hebrew and Roman alphabets. The intention was simply to find a harmony on the plane of *speech* whilst being able to employ different languages. The letters all centre on the body height as a compromise between the two traditions of sitting on the baseline and appearing to hang from the cap height.
Below – Cover and inside front page of a double fronted booklet which reads either left to right or right to left.
Bottom – A series of posters from Tel Aviv where work in progress was recreated on city walls as a desktop. The metaphor of sharing water from two sources is a particularly potent symbol in Israeli politics.
Opposite – A series of posters designed to announce the final font.

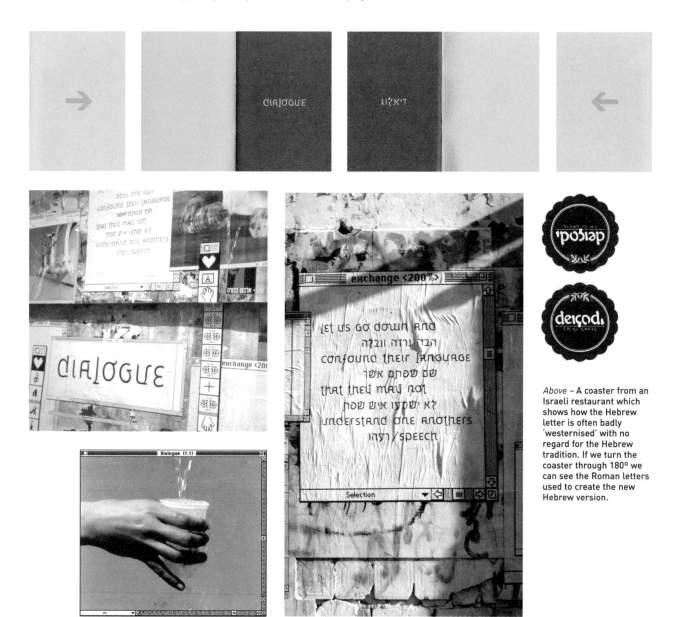

Above – A coaster from an Israeli restaurant which shows how the Hebrew letter is often badly 'westernised' with no regard for the Hebrew tradition. If we turn the coaster through 180º we can see the Roman letters used to create the new Hebrew version.

Michael O'Shaughnessy
**Illustration, Craft &
Technology**
connotation

Poster for an illustration
conference entitled
'Illustration, Craft &
Technology'. The agenda
of the event was to debate
the relationship between
traditional and digital
technologies in contem-
porary illustration.
The poster is encoded
with a range of signs
which allude to each set
of technologies. It also
suggests the process of
'making' by the nature of
the mark making
employed and the inclu-
sion, around the edge, of
elements which have
been edited out and left
unused on the paste-
board.
On a *denotative* level it is
merely text yet on the
connotative level the
reader picks up a range of
signals.

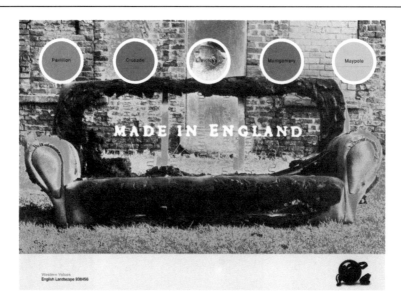

Western Values
English Landscape 938456

David Crow
Made in England
language and speech

A page from an exhibition
catalogue which sets up
tensions between the
linguistic signs and the
images. The text 'Made in
England' is usually featured
as a sign of quality and
tradition. In this case it
is interrupted by the
documentary photograph
of a burnt-out sofa. This is
underpinned by the use of
words such as 'crusade'
and 'pavilion' which
appear to describe
colours but also portray
a highly nostalgic and
nationalist view of history.
The teapot is used as a
reference to the building
of the British Empire.
The parody of advertising
is completed by placing
the teapot in the bottom
corner where we
would expect to find a
corporate logo.

text and image

4

4. text and image

For linguists codes must be digital, that is to say that they are composed of a fixed number of digits or units. In 'Image, Music, Text'[1], Roland Barthes asks whether it is possible to have codes which are analogical.

1. Barthes R.
Image, Music, Text (1977)

codes

Digital codes are paradigms where each of the units in the set are clearly different from each other. (As we saw in chapter 2 the two basic characteristics of a paradigm are that the units in the set have something in common and each unit is obviously different from the others in the set.) The alphabet is arguably the most common example of a digital code.

Analogue codes are paradigms where the distinctions between each unit is not clear, they operate on something more like a continuous scale. Music or dance, for example, could be described as analogue codes. However many analogue codes are reduced to digital codes as a means of reproducing them in another form. Musical notation, for example, reduces the analogue qualities of sound to distinct notes with individual marks.

To examine the relationship between text and image, Barthes chooses to focus on compositions from advertising. In advertising the reader can be sure that signification is always intentional. Nothing is left to chance. It is the purpose of the advertisement to communicate the positive qualities of the product as clearly as possible to the chosen audience. This is demonstrated by Frank Jefkins' three basic principles of effective advertisement writing;

1. The advertisement should be of interest and value to the reader. The writer should ask himself, 'How can I interest my prospects in my proposition? How can my offer be of service to prospects?'

2. The advertisement should be precise, that is, get to the point as quickly as possible; hence the success of the most hard-worked word in advertising, FREE!

3. The advertisement should be concise, saying what it has to say in the fewest necessary words, remembering that an encyclopaedia of many volumes can be concise compared with a verbose novel. 2

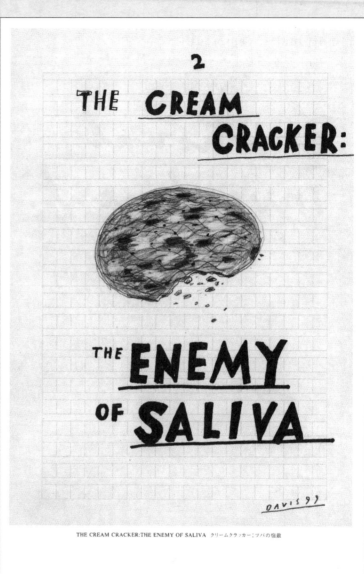

THE CREAM CRACKER:THE ENEMY OF SALIVA　クリームクラッカー：ツバの宿敵

2. Jefkins F. *Advertising Writing* (1976)

The Linguistic Message

Barthes sets out a system for reading text/image combinations which comprises of three separate messages. The first message is described as the 'linguistic message'. This is the text itself, usually in the form of a slogan or a caption to the image. Reading the linguistic message requires a previous knowledge of the particular language employed i.e. French, German, English. The linguistic message can also carry a second order signifier by implication. For example, an advertisement featuring the word 'Volkswagon' tells us the name of the manufacturer but also signifies certain national characteristics. Notions of high design standards and precision engineering are read at the same time as the name.

The Coded Iconic Message

The second message is the 'coded iconic message'. This is a symbolic message and works on the level of connotation. The reader is playing a part in the reading by applying their knowledge of the systematic coding of the image. An image of a bowl of fruit for example might imply still life, freshness or market stalls.

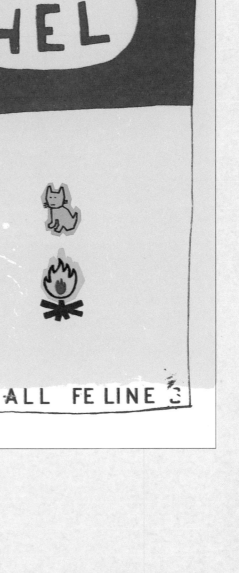

Paul Davis
Wasteland

The text answers the question 'What is it?'. Our attitude to the humble cracker is fixed by the addition of a copy line in a parody of advertising (see **Anchorage** p. 76).

Alan Murphy
Feline Hell

The innocuous drawing of the cat and the flames are changed by the addition of the text calling for an end to the breed. Without the text the cat could almost be keeping itself warm. The advertising parody is reinforced by the addition of the stylised 'HEL' which has the character of a brand name.

the three messages

The Non-Coded Iconic Message

The third message is described as the 'non-coded iconic message'. A photograph for instance could be described as a message without a code, one simply reads the medium as itself; it is a photograph. This works on the level of denotation.

Although the linguistic message can be easily separated from the other two messages Barthes maintains that the other two cannot be separated because the viewer reads them at one and the same time. In other words, the medium cannot be separated from the message; a phenomena Marshall MacLuhan pointed to in his book 'The Medium is the Message' [3].

Text, according to Barthes, constitutes what he calls a 'parasitic' message on an image, designed to quicken the reading with additional signifieds. Hence the addition of text can be a powerful method of altering or fixing the meaning of an image. This is something which is present in a great number of the images we read; in captions, subtitles, film dialogue, comic strips etc. However it seems that neither the length of the linguistic message (the text) nor its position are particularly important, but merely the presence of the linguistic message. Indeed it is possible that a long text may only comprise of one message, a single global signified. When coupled with an image, text has two possible functions, anchorage and relay.

Anchorage

Anchorage, says Barthes, directs the beholder through a number of possible readings of an image, through what he calls a 'floating chain of signifiers' and causes the reader to ignore some of the signifiers and read others. The text answers the question 'What is it?'.

To the connoted image (the coded iconic message) the text helps the reader to interpret the signifiers they are presented with. To the denoted image (the non-coded iconic message) it aids recognition. He describes the way in which the reader is remote controlled to a meaning which has been chosen in advance. He points out that this often has an ideological purpose. Anchorage text has then a repressive value in inspecting an image.

Relay

The second possible function, 'relay', is much less common. The text is usually a snippet of dialogue and works in a complimentary way to the image. It can be found in things like comic strips and is particularly important in film. Relay text advances the reading of the images by supplying meanings which are not to be found in the images themselves, as in film dialogue.

3. MacLuhan M. and Fiore Q. *The Medium is the Message* (1967)

anchorage and relay

Neil Morris
Metastasis
anchorage

The addition of text to
these screen prints
guides the reader to the
intentions of the artist and
helps the reader to
decode what is otherwise
a highly personal visual
language of open signs.
(see also **Open Work** –
chapter 9).

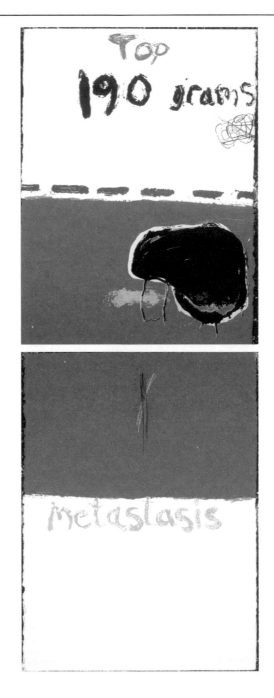

Visual Research
We Interrupt This Programme
anchorage

Series of posters promoting events for an educational project. The posters offer visual clues to the content of the project. The images are chosen to reflect local concerns for each stage of the project as well as reflecting the underlying content. These are juxtaposed with single words which give the reader a relationship between text and image for them to create a relevant meaning from the variety of possible readings of these complex combinations.

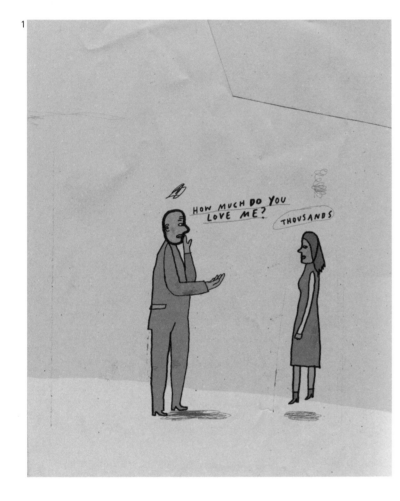

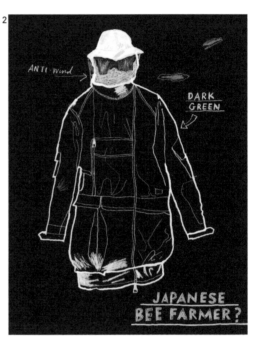

1. Paul Davis
Conversation
relay

In this snapshot of
overheard conversation
there is very little visual
information to advance
the narrative and the
reader relies instead
on the text for the
information.

2. Paul Davis
Bee Farmer
anchorage

In this example the text is
used to fix the reading of
the image. The colour of
the jacket for example is
not given as a visual sign
as the reader might
expect but given instead
as a linguistic sign.

3. Alan Murphy
77th Black Dawn Disaster
relay

The images work in a
similar way to a series of
film stills where there is
nothing which visually
advances the narrative.
With no sound the viewer
would have very little idea
of what was happening.

official language

official language

5

5. official language

Pierre Bourdieu classified human endeavour and knowledge in terms of fields. Some fields are clearly defined by making entry into that field difficult to attain, and in general, the more difficult the entry then the more defined the field. The field of law might be considered a clearly defined field. Those in the field could be said to be sharing or struggling with a common pursuit and share in its own particular 'discourse'. The visual arts would be described as an activity that takes place within the 'field of cultural production'. Like all the other fields, this field is constantly changing, as is its membership and its 'discourse'.

1. Bourdieu P. *Intellectual Field and Creative Project* (1971) in Young M.F.D. *Knowledge and Control* (1971)

habitus

Habitus

The notion of creative and intellectual fields was extended to establish the idea that each field pre-exists its membership, in the case of the field of cultural production, the field pre-exists the artist. Within the field there are a number of official positions, graphic designer, for example, which offers a range of possibilities. These possibilities are however limited by a number of factors such as education, social background, gender and age. This influences choices whilst also reinforcing the validity of the field. It is generally agreed that individuals carry with them some idea, perhaps subconscious, of which position to take up on their arrival within the field. You could call this a sense of vocation. It is this sense of vocation that became described as 'habitus'. Bourdieu states that choice between these territories, where we will take up position as individuals, the choice of habitus within the language is accomplished without consciousness with each situation. [1] Apparently insignificant aspects of everyday life, e.g. ways of doing things, body language together with the constructed images we witness every day all contribute to the formation of 'habitus'.

legitimate language

The Production of Legitimate Language

Bourdieu [2] begins his assertions about Legitimate Language with Saussure's observation that neither languages nor dialects have natural limits. All that is necessary is a set of speaking subjects who are willing to make themselves the bearers of the language or dialect using an intrinsic and autonomous logic. Bloomfield [3] describes this as a 'linguistic community – a group of people who use the same system of linguistic signs.'

Bourdieu however goes on to point out that external as well as internal factors affect the limit of a language and that externally there is a political process which unifies the speaking subjects and leads them to accept, in practice, the use of the 'official language'. In order to successfully impose this language as the official language it is necessary to have a general codification that is sustained by creating institutional conditions which enable it to be recognised throughout the whole jurisdiction of a certain political authority. It follows that this official language has territorial limits. An unofficial language, a dialect for example, has however not undergone this institutional process of control, it is internally driven by its own independent logic. We will look at this in more detail in chapter 6. The official language imposes itself as the only legitimate language within a territorial limit. In the context of this book, this territory could be described as the field of cultural production and the territory which surrounds or includes various positions within that field i.e. graphic designer, fine artist. This is particularly true of situations which characterise themselves as

108
▼

being 'official'. This will be discussed further in this section of this book.

Grammarians and teachers working from institutions become jurists who examine the usage of language to the point of the legal sanction of academic qualifications which identify the legitimate language within a territory and enable individuals to take up positions within a field. If we look at the vocational art and design disciplines such as graphic design or fashion design, in most cases entry into the field is acquired through the successful completion of an academic qualification like a degree or a diploma. The process of completing the course generates a portfolio which is used in selection at interview but in most cases the interview is only possible once the award has been attained. The use of language, both written and visual language, has been judged and sanctioned by an institution.

'The educational system, whose scale of operations grew in extent and intensity throughout the nineteenth century, no doubt directly helped to devalue popular modes of expression, dismissing them as "slang" and "gibberish" (as can be seen from teachers' marginal comments on essays) and to impose recognition of the Legitimate Language.' [4]

Recent shifts in bilingual education in the USA illustrate this well. In an essay entitled Language Wars [5] Rene Galindo points out a number of propositions passed in the late 1990s. A 'California English Only' initiative (proposition 63) was followed by a provision

2. **Bourdieu P.** *Language and Symbolic Power* (1991)

3. **Bloomfield L.** *Language* (1958)

4. **Bourdieu P.** *ibid.*

5. **Galindo R.** *Language Wars: The Ideological Dimensions of the Debates on Bilingual Education* (1997)

the page itself is a sign

The book of Genesis tells the story
of the Tower of Babel. At that time
all the citizens spoke the same
language and everyone could
understand each other. To celebrate
this they decided to build a tower
which reached towards the heavens.
God in his wisdom decided that
this must be stopped. To do this
the most effective method was to
fragment their language so that
hierarchies would develop.
Of course, linguists do not take the
story to be an accurate historical
text but it serves as a useful
metaphor of how language can be
used as an instrument of control.

capital

for citizens and anyone doing business in the state to sue local governments for actions that diminish or ignore the role of English as the common language of California. Proposition 227 called 'English for Children' passed in 1998 decreed that all children should be taught English and anyone who wants their children to be taught a second language would have to make a special written request. Galindo summarises the debate as;

> '...the competition for value between different constituencies that takes place through the manipulation of symbolic assets such as language(s)...' [6]

This competition for value can also be seen in the way slang is included in dictionaries as recognised omissions from 'legitimate language'. They often appear in italics, a typographic signal of difference or separation, as popular or common uses. Indeed any value or 'capital' (cultural or monetary) awarded to individuals always arises from a deviation from the most common usage. Commonplace usage is seen as trivial or vulgar. Capital (i.e. qualifications) is awarded to well-chosen words/signs/images which are seen as dignified or lofty. As the educational system is funded by and answerable to the state then it could be said that the production of a 'legitimate language' is bound up with the affairs of the state, the field of economic production.

> 'Obligatory on official occasions and in official places (schools, public administrations, political institutions etc.), this state language becomes the theoretical norm against which all linguistic practices are objectively measured.' [7]

It is worth noting that the highest proportion of graffiti attacks (an extreme form of unofficial visual language) take place in schools, the institutions responsible for the maintenance of the official language and on local authority (state) property.

Bourdieu points out that for a particular language or a particular use of language to impose itself as the legitimate one, the different dialects, whether class, regional or ethnic group, have to be practically measured against the legitimate language. Without support from external agencies these dialects or unofficial languages (which are internally driven) cannot be imposed as the norm for another territory despite the possibility of using these differences as a pretext for declaring one superior to another.

The theory follows that these differences can be developed into a system for determining hierarchical position.

If we look, for example, at the appearance of the visual language of the Pop artists in the 1960s and the criticism which now accompanies this work we can see the way in which the discourse surrounding the work has developed to authorise the work and enable its acceptance as part of the official visual culture.

6. Galindo R. *Language Wars: The Ideological Dimensions of the Debates on Bilingual Education* (1997)

7. Bourdieu P. *Language and Symbolic Power* (1991)

capital

Society awards 'capital' to individuals for their use of language. This can be monetary or cultural capital. In the case of good use of the 'Official' language an educational award such as an honours degree or a Phd could be the cultural capital leading perhaps to monetary rewards. The reverse is also true for the use of an 'Unofficial' language such as graffiti or vandalism where a spell in detention could be the reward.

In its open celebration of popular culture, pop art caused a great deal of consternation amongst those at the centre of the field of cultural production.

> 'There was a widely held view in some circles in the 1950s that serious paint-ing had to be abstract, that it was ret-rograde for artists to make reference to the outside world by engaging in representation or illusion.'[8]

The British artist Peter Phillips was studying at the Royal College of Art in London, the most prestigious art school in the UK, marked by its Royal Charter. When he first produced what has become known as some of the finest examples of British Pop Art he was castigated by his tutors. Their disapproval was so strong that Phillips was forced to transfer to the popular, and less noble, art of the Television School for his final year. The celebrated David Hockney was threatened with expulsion at around the same time for his refusal to complete (official) written work. Allen Jones fared less well and was expelled from the college. Compare this attitude towards the work with these excerpts from a recent critique on the same work.

> 'Phillips painted a large canvas, Purple Flag, in which he synthesised his practical skills and his intuitive response to Italian pre-Renaissance painting with an open expression of his enjoyment of funfairs and the game of pinball...The smaller motifs incorporated in the lower half of the painting...establish an alternative timescale as in early Italian altar pieces, in which predella panels establish a narrative compliment to the starkly formal central image.'[9]

This method of referencing the past is commonplace in artistic criticism and appears to lend authority to the work by aligning its formal features with those which are already accepted as part of the official discourse.

> 'Some of the recurring characteristics of Pop...were anticipated in a variety of developments in European and American Modernism. The basing of images on existing popular sources, for example, had precedents in the work of nineteenth-century painters such as Gustav Courbet and Edouard Manet.'[10]

rules

Visual arts publications which deal with the craft of making visual work invariably carry sets of rules on how to successfully employ the official visual language within their various disciplines. Of course many of these accepted conventions are grounded in experience and are valid observations. The important thing to recognise in the context of this chapter is that there are rules which have become accepted as legitimate practice and are used in education and elsewhere as the norm against which deviation is measured. Here are some examples from graphic design texts;

> '...the efficiently designed trade-mark must be a thing of the barest essentials.'

> '...useless elaboration that has been traditionally a feature of bad trade-mark design.' [11]

> '...typefaces can unquestionably be assessed on the basis of artistic quality irrespective of their fashion status; and, conversely, no amount of fashion-able success can change this assessment for better or worse.' [12]

> 'Visual analogies which most clearly illustrate meaning or the spirit of a word should be sought; for example, the letter O could be the visual equiv-alent of the sun, a wheel, an eye.' [13]

Any value or 'capital' (cultural or monetary) awarded to individuals always arises from a deviation from the most common usage. Commonplace usage is seen as trivial or vulgar.

8. Livingstone M. *Pop Art* (1990)

9. Livingstone M. *ibid.*

10. Livingstone M. *ibid.*

11. Horn F.A. *Lettering at Work* (1955)

12. Hutchings R.S. *The Western Heritage of Type Design* (1963)

13. Rand P. *A Designer's Art* (1985)

14. Foucault M. *The History of Sexuality* (1979)

15. Bourdieu P. *Intellectual Field and Creative Project* (1971) in Young M.F.D. *Knowledge and Control* (1971)

The Competition for Cultural Legitimacy

It was generally agreed that the social uses of language owe their social value to their being organised into systems of differences. To speak is to adopt a style which already exists and is marked by its position in a hierarchy of styles which corresponds to a hierarchy of social groups. In a sense then these different styles/dialects are both classified and classifying by marking those who use them.

Foucault [14] points out that the biological distinction of gender has been overlaid with a systematic set of discourses which have become an organising principle in organising labour, consuming and producing goods leading to gender dominated practices.

In 'Knowledge and Control' Bourdieu outlines a competition where the public is seen as both the prize and the arbitrator, a competition in which competitors cannot be identified with the competition for commercial success.[15] This is certainly true of the experiences of designers within the field of cultural production where work which can be identified as commercial is subject to varying degrees of derision. This is perhaps even more intense in the fine arts where there is reluctance to acknowledge that art is a commercial activity. This declared refusal to meet popular demand could encourage art for arts sake and increase the intensity of emotions between members of an artistic community. Mutual admiration societies appear which are inevitably accompanied by formal award ceremonies as a result of artists addressing an ideal reader.

Flux

Another condition which Bourdieu offers as essential to maintaining the permanence of an official language is the need for a process of continuous creation and review through a continuous struggle between the different authorities within a field of specialised production. A field must be in constant flux to be able to survive. So although one cannot be seen to be identified with wholly commercial issues there is however a practical commitment to the economic field (advertising, constructed realities, work ethic) by the constant drive to maintain the status quo at the centre of a specialised field such as the visual arts. The example of the reception given to Peter Phillips' work is part of an endless process of assimilation which is necessary for the field to maintain its authority. Carl Andre's pile of bricks was finally accepted when the Tate Gallery bought the second version of the piece in 1972 despite the ridicule which heralded the first version in 1966. By 1976 the bricks were exhibited alongside paintings by John Constable in the gallery in London. The history of the field of cultural production is littered with similar examples.

The relationships between different agents within a specialised field (i.e. publisher /author, painter/curator) leads us to question the traditional perception of 'authorship' which Bourdieu describes as 'collective' with each agent or partner employing the socially established idea of the other partner. This judgement being a representation of their place within the particular specialised field. He provides us with examples of activities which fall between noble, cultural activities and vulgar, commonplace activities in the form of photography and cinema. The divided opinion and controversy between the cultivated classes is used to place photography half way between the poles of high and low culture. The position of photography would then determine the relationship between the photographer and the painter. Although it could be argued that photography has become more acceptable to those at the centre of the field of cultural production since 1991 (when Bourdieu wrote 'Language and Symbolic Power') there remains evidence of a reluctance to fully accept the media into the fine arts. This can be seen through the varying degree to which it is resourced in art colleges throughout the UK with some colleges providing distinct pathways for photographers and film/video makers while others make no practical provision at all.

95

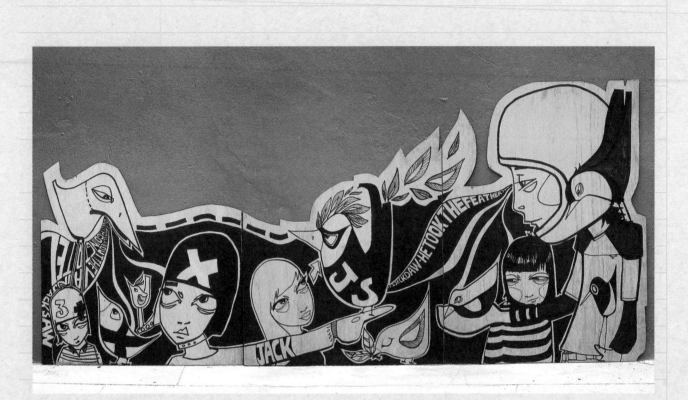

The acclaimed designer Paul Rand points out that there remains a discernable hierarchy within the practices which make up the visual arts.

'That graphic design is generally considered a minor art has more to do with posturing than it does with reality. The paucity of great art is no more prevalent among designers than it is among painters. To be sure there is a basic difference between graphic design and painting. But that difference is one of need and does not preclude consideration of form or quality. It merely adds more stress to the normal difficulties entailed in producing original work.' [16]

This perception is built on historical ideologies which show an outright contempt for artistic works with any functional value.

'Nothing is truly beautiful except that which can serve for nothing.' [17]

Although institutions like the Arts Council in the UK were set up with the aim of making the arts more accessible to society regardless of class Paul Willis points out that:

'The Arts Council withdrew very promptly from the site of popular consumption.' [18]

However, Willis also points out that this high culture cannot ignore low culture.

'"Elite and official" culture can no longer hope to colonise, dominate or contain everyday life because there is already something there which grows from its own resources – a meaning-making and ordinary cultural production now full of implications for the rest of society.' [19]

Lucy McLauchlan
Jackdaw

It is generally accepted that a designer works in a 'commercial' area and artists make work which is 'issue based'. Jackdaw is an example of how a designer/illustrator develops their own visual language through exploring issues such as new media, subject matter or scale. This work is based on Aesop's fable 'The Vain Jackdaw' and is 2x0.8m in size, black marker pens on plywood.

16. Rand P. *A Designer's Art* (1985)

17. Gautier T. (1811–1872) in Rand P. *A Designer's Art* (1985)

18. Willis P. *Common Culture* (1990)

19. Willis P. *ibid.*

20. Austin J.L. *How to do Things with Words* (1955)

Being able to recognise and employ Legitimate Language does not necessarily empower the speaker/artist without another set of conditions. The words themselves have no power unless the user is 'authorised' to use them.

Authorised Language

It is obvious that social conditions and social ritual have a bearing on the use of language. It is a principle of drama that the nature of acts must be consistent with the nature of the surroundings. This phenomena can certainly be observed within the institutions, mentioned earlier, whose role it is to impose, defend and sanction legitimate language. The lecture theatre provides an excellent example of Burke's observations on drama. The theatre, the lectern, the books are all instruments of an official discourse deemed worthy of publication. The lecture is granted as legitimate not by being understood but by being delivered by an authorised and licensed (qualified) person in a legitimate situation. One notion which is particularly good at highlighting this is what Bourdieu calls 'the magical act'. This is described as the attempt, within the sphere of social action, to act through words beyond the limits of delegated authority. The visual arts is full of examples of the magical act where the semiotics of the official and the corporate have been skilfully employed to communicate the ideas and feelings of the individual.

'Suppose for example, I see a vessel on the stocks, walk up and smash the bottle hung at the stem, proclaim "I name this ship the Mr Stalin" and for good measure kick away the chocks: but the trouble is, I was not the person chosen to name it.' [20]

Katy Dawkins
Interference (Plaque)
authorised language

One from a series of
interventions in public
spaces. The original text
is taken from graffiti
found in various parts of
the city and is then
returned to the original
location using the
characteristics and the
materials of an official
visual language.
This ability to transfer a
message from unofficial
language to official
language is described as
the *magical act*.

Katy Dawkins
Interference (Bench)
authorised language

Katy Dawkins
Interference (Toilet)
authorised language

Joe Magee
**The Daily Telegraph,
January 2002
(Renationalise!)**
magical act

The first in a series of
illustrations to accompany
a consumer column in
The Daily Telegraph
newspaper. The column,
'Road Test', compared
approximately five
items made by different
manufacturers to
determine the best buy.
The subject for this one
was 'winter coats'. The
braille text reads
'Renationalise!'.

The illustrator used the
braille text to encode
each image with a hidden
message which was at
odds with the political
leanings of the newspaper.
The contract for the column
was brought to an abrupt
end when they eventually
discovered the hidden text.

Joe Magee
The Daily Telegraph
February 2002
(Thatcher Fucked Us)
magical act

The sixth in the 'Road
Test' series, the subject
for this week was 'hair
conditioner'. The braille
text reads 'Thatcher
Fucked Us'.

David Grossman
and Yaki Molcho
**Valley of the
Communities**
official language

The National Holocaust
Memorial Site in
Jerusalem. An inventive
interpretation of the
traditional war memorial.
The typography is
placed according to the
geography of the
European communities
involved. All the signs
of an official public
sculpture are employed.
The permanence of the
materials and the crafts-
manship of the typography
all lend gravitas to the
design of 100 walls in
three valleys.

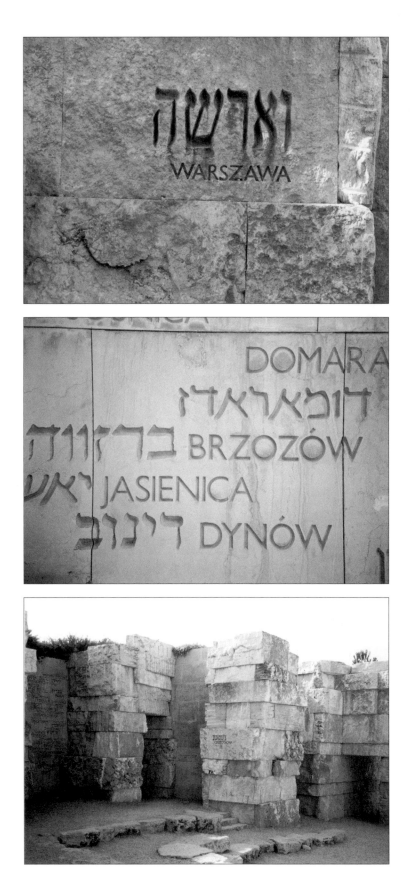

unofficial language

6

All of us face the problem of a 'differential fit' between how we see ourselves and how others see us. Where we try to solve this problem individually it can lead to isolation, but solving the problem collectively offers us a new perspective on the situation.

Unofficial Codes

Mike Brake [1] points out that the 'differential fit' problem is redefined according to the rules and conventions of the subcultural group and offers us a new identity outside of the usual categories of age or class or occupation. Young people in particular feel marginalised by official cultural values. They often place no importance on work, even as a means of earning money, and turn instead to leisure-based rather than work-based activity. Increasingly their aspirations are focused on what they do outside of the workplace. Their energies are directed toward activities associated with music, fashion and sport. Often two or more of these are fused together in a semiotic package.

The football terraces for example are lively and colourful places, densely packed with fans adorned in team colours. On one level this merely signifies the team they support. However, studies involving the behaviour of football fans show that there are a number of subtle messages being communicated. The way the colours are worn, how the scarf is

1. **Brake M.** *Sociology of Youth Culture and Youth Subcultures* (1980)

tied, the gestures made by the fan and the way they dress are all part of a semiotic code. Studies have shown that it is possible to predict which fan would stand and fight, which regularly attends away matches and which fan sees themselves as tough but probably aren't by looking at these semiotic subtleties.

'Although the fans dress in a similar manner which accords with certain conventions and styles they are still able to convey a wide range of messages in their choice of clothing which fall within the wider conventions. In other words the 'gear' that the fans wear has a highly symbolic function.' [2]

The gestures between rival football fans work as metonyms. The clenched fist and the frosty stare are all recognisable as metonyms for real violence and can stand in instead of violence in ritualised aggression.

As we saw in the previous chapter, Saussure observed that neither languages nor dialects have natural limits. All that is needed is a set of speaking subjects who are willing to make themselves the bearers of the language/dialect. The symbolic gestures discussed in this chapter can be seen as 'dialects'. A whole range of semiotic symbols marks the distinct linguistic communities. What they wear, how they talk, their gestures, their haircuts are all part of their particular dialect. The language, whether spoken or visual, is determined by the community who use it and, unlike the official language, it has

no control imposed from the outside. It is easy to see why this is an attractive proposition for anyone who feels marginalised by official culture in some way. The opportunity to communicate with like-minded people in a way which cannot be understood by those you mistrust. By its very use the language also marks the user as part of an alternative community.

Graffiti

Let's look, for example, at graffiti as an unofficial visual language which also carries its own linguistic terms. Graffiti is a useful model as it is first of all distinctly visual. It also has the benefit of being an extreme type of unofficial language. It stands well outside of any educational system. This makes it easy to recognise and gives equally clear reactions from those who read it.

'Writing graffiti is about the most honest way you can be an artist. It takes no money to do it, you don't need an education to understand it and there's no admission fee.' [3]

The demonstration of individual identity is perhaps the most popular and prevalent theme of graffiti writing. The time-honoured practice of writing your name (or nickname) is still very much part of our environment today and has a history which goes back to the names of gladiators accompanied by symbols and pictures which were scratched

2. Marsh P. and Rosser E. and Harré R. *The Rules of Disorder* (1978)

3. Manco T. *Stencil Graffiti* (2002)

4. Castleman C. *Getting Up: Subway Graffiti in New York* (1982)

into the walls on the excavated buildings of Pompeii.

Castleman's study of New York graffiti identifies a number of forms of contemporary graffiti such as the 'tag' or the 'throw-up'. This terminology used by graffiti writers extends to highlight a hierarchy and a code of practice peculiar to their own 'field':

Getting Up – *writing*

King of the Line – *the writer with the most number of throw-ups*

Backgrounding – *an agreed code not to cover or deface other people's work*

Racking Up – *shoplifting (It is considered proper that the materials used should be stolen.)*

Hit – *early name for a tag*

Fame – *fame*

Nasty, the Death, Vicious, Bad, Dirty, the Joint, Juicy, Down, Burner, On – *terms of approval*

Toy – *a term which can be added to a piece as a form of criticism, meaning insignificant*

Bomb – *a group attack* [4]

the graffiti writer

5. Hurd D. (then UK Home Secretary) *Conference on Vandalism, London* (1988)

6. Home Office Research Unit in Coffield F. *Vandalism and Graffiti* (1991)

7. Coffield F. *Vandalism and Graffiti* (1991)

8. Castleman C. *Getting Up: Subway Graffiti in New York* (1982)

9. Castleman C. *ibid.*

10. Criminal Justice (Scotland) Act of 1980 (Section 78)

The Graffiti Writer

The official view of the graffiti writer is that he or she is a vandal. It seems to follow a stereotypical description of a working-class inner city adolescent whose destructive activities are the forerunner for criminal activities in later years.

'...it is easy to see how today's young vandal can become tomorrow's football hooligan and next week's mugger.' [5]

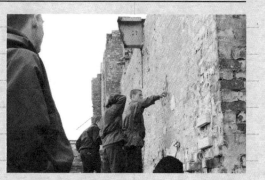

The British Home Office Research Unit literature confirms this view:

'The motivation underlying vandalism by adolescent youths may also fuel other forms of delinquent behaviour, especially theft...' [6]

However, this stereotype is discredited by independent studies which claim that the vandals have a much broader social background.

'Vandals come from urban and suburban as well as rural areas, from working-class and middle-class as well as upper-class families, and are of different ethnic origins. A recognition of the growing involvement of girls in vandalism would also help to correct the stereotype.' [7]

This view is certainly backed up by the high proportion of involvement shown in Gladstone's self-report study in 1978 and also confirmed by Craig Castleman's study of New York graffiti. Officers from the transport police talked about the vandals and described what kind of backgrounds they came from:

'...their fathers were professors at Columbia, NYU, some were CPAs, some were doctors, architects. They live in thousand-dollar houses, apartments, some are living in $1.98-a-month ghettos. There's no generalisation.' [8]

According to Castleman, The Nation of Graffiti Artists (NOGA) has members representing numerous ethnic groups:

'including Chinese, Americans, West Indians, Ukrainians, Filipinos, Dominicans and Nigerians.' [9]

The police records also showed that the majority of writers were between 11 and 16. The writers themselves confirmed this in interviews with Castleman. They tended to start around ten years old and retire by their 16th birthday, this being the age at which, as adults, they would be photographed and fingerprinted, effectively criminalised.

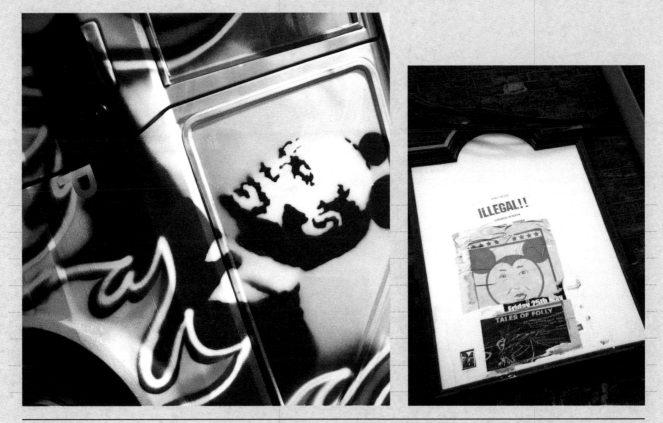

Motivation

Perhaps the most striking feature of this area is that there is no general view about the causes and motivation behind graffiti and vandalism. There is no single theory that is generally accepted as having unlocked the secrets of these illicit activities. Rather, there are a number of approaches that attempt to explain either part of the problem or a particular type of vandalism. There is also no general agreement of a definition of vandalism. For example, criminal statistics for England and Wales show that no one has ever been charged or found guilty of 'vandalism' whereas in Scotland 'vandalism' has been a criminal offence since 1980. In England and Wales graffiti and vandalism have been defined in terms of 'criminal damage' yet the Criminal Justice (Scotland) Act of 1980 (Section 78) clearly states:

'Any person who, without reasonable excuse, wilfully or recklessly destroys or damages any property belonging to another shall be guilty of the offence of "vandalism".' [10]

Despite this difference in legal terminology the news reports and press cuttings show that it is typically described as 'senseless', 'mindless' or 'obscene' both by journalists and by the police. These terms are rarely used, however, when reporting the efforts of city planners or developers who have damaged cities/landscapes more permanently.

This vandalism with power was highlighted by David Downes extending traditional concepts of vandalism to include what he called 'Pinstripe Vandalism'. In general then there is a tendency for official institutions and authorities to view vandalism and graffiti as a 'problem' and to address the issues using a discourse which reflects this view. Stan Cohen and Frank Coffield, however, suggest that vandalism and graffiti are 'solutions' rather than problems, which provides a perspective that differs from the usual approach of prevention and punishment.

Prestige and Excitement

Home Office Research in the UK cites 'prestige and excitement' as motives for graffiti and vandalism:

'...most of the vandalism seems to be committed either by young children in unsupervised play, or by older adolescents seeking prestige and excitement; relatively little seems to be committed by older youths or adults.' [11]

A study of workers on the Liverpool docks showed that a system of rules and conventions, generated by financial hardship, led to a tradition of risk taking as proof of strength, courage or skill. This tradition was especially focused on defiance toward authority and institutions. A code of practice was established where it was quite acceptable to steal something from the workplace but entirely

unacceptable to steal from the family.
One other point was made by the UK Home Office Research Unit which is particularly interesting as a clue to possible motives:

'...a comparatively small proportion of vandalism appears to be committed against people's personal or private property...most vandalism is directed at local authority property.' [12]

We begin to get a broad picture of graffiti as a series of gestures directed against the visible symbols of the establishment. These are motivated, at least in part, by the need for excitement or prestige amongst his or her own particular linguistic community.
There have been a number of attempts to define the motives behind vandalism by firstly categorising the variety of actions which come under this heading and then dealing with why these take place. Perhaps the most accepted formulation of categories are the types outlined by Cohen which were later adapted by Baker and Waddon (whose alterations I have added in italic to Cohen's original list);

1. Ideological Vandalism
Property which is destroyed to gain publicity for a particular cause which is justified by a political belief or a long-standing grievance.

2. Acquisitive Vandalism
To acquire money or property e.g. looting vending machines, stealing signs.

3. Tactical Vandalism
Baker and Waddon replaced this category with a new category; 'Graffiti'. A means of achieving some other end e.g. bringing a production line to a halt in order to break the boredom of the work, to increase standing within their peer group.

4. Vindictive Vandalism
Baker and Waddon changed the title of this category to 'Problem Expression'. Vandalism for some form of revenge or to settle a grudge, often directed at schools.

11. Home Office Research Unit in Coffield F. *Vandalism and Graffiti* (1991)

12. Clarke R. (1978) in Coffield F. *Vandalism and Graffiti* (1991)

13. Baker C. and Waddon A. *Vandalism: Understanding and Prevention* (1989)

14. Hurd D. (then UK Home Secretary) *Conference on Vandalism*, London (1988)

categories of graffiti

5. Play Vandalism
Vandalism for fun or through high spirits which is motivated by curiosity or competition. e.g. who can break the most windows.

6. Malicious Vandalism
For Cohen this is the category which includes the behaviour of young people who are 'breaking out, breaking away or breaking clear' and would include the attacks on local authority property. He recognises this to be the category which is most difficult to understand as it appears to be 'meaningless' but provides an opportunity for them to express their boredom, frustration or despair with little chance of being caught and convicted.[13]

As I have already stated there seems to be no general view about the causes and motives underlying vandalism, however, from the above list we can identify a number of possible motives – financial gain, peer group pressure, aesthetic pleasure and manufactured malice. Douglas Hurd's view in 1988 was that the causes were;

> *'boredom, stupid drinking and young people's appetite for excitement.'* [14]

However, the motives which generate most debate are the notions of pleasure and manufactured malice. The argument is that vandalism as a solution to this group's problem is just 'right', both in symbolic, expressive or emotional terms. That is, in its very senselessness, it makes sense... in terms of what it offers; excitement, trouble, toughness, action, control and risk.

We have a picture of what society should be and we recognise certain motives as legitimate. Where these motives cannot be found then the behaviour cannot be tolerated. Vandalism which does not involve financial gain (this would include graffiti) is then seen as motiveless. The only way then of making sense of some actions is to assume that they do not make sense under conventional logic.

visual dialect

ACHTUNG!
PLAKATIEREN
VERBOTEN!
JEDE UNAUTORISIERTE NUTZUNG IST
RECHTSWIDRIG UND VERPFLICHTET ZUR
ZAHLUNG EINES WERBENUTZUNGSENTGELTS
GEM. § 812 BGB UND ZUR ZAHLUNG VON
SCHADENERSATZ GEM. § 823 BGB UND WIRD GRUND-
SÄTZLICH STRAFRECHTLICH GEM. § 363 STGB VERFOLGT.
AUFTRAGGEBER HAFTEN FÜR IHRE ERFÜLLUNGSGEHILFEN.

Visual Dialect

One formal feature which is common to most graffiti is the materials used to make the work. The nature of the act dictates that the marks have to be made quickly with materials which can be easily carried and concealed, and are readily available. In addition to scratching, the most popular materials are spray paint and more recently the marker pen, which can be customised to give a desired effect (i.e. chiselled or taped together). It is worth noting that flyposting is never mentioned as a form of graffiti and as Castleman observed, the transport police did not target sticker campaigns. Whether this is due to the permanent nature of graffiti tools, or the fact that many commercial or political campaigns use print-based (official) media remains unclear. What is clear is that flyposting also has many of the features of graffiti.

'Flyposters have provided a cultural form which those on the fringes of, or totally outside dominant cultures, have been able to use with great effect. The uses have varied from person to person and from situation. The common characteristic is that flyposters are a medium for groups or individuals with little money or access to the established media. They are exciting, dangerous and subversive.' [14]

Stencil graffiti carries a similar set of semiotic values. As Tristan Manco points out in his book on stencilling, the medium is readily associated with the stencil lettering to be found on functional packaging and urban street furniture. This gives the stencil an authority and an authenticity with the added benefit of consistency. Like the flyposter, our awareness of their history makes them exciting and subversive.

14. Fuller M. *Flyposter Frenzy* (1992)

15. Manco T. *Stencil Graffiti* (2002)

'All graffiti is low-level dissent but stencils have an extra history. They've been used to start revolutions and to stop wars. They look political just through the style.' [15]

The possibilities in loading messages with these second-order signifiers (danger, subversion, dissent, authenticity, politics) has certainly not been lost on manufacturers and advertisers. The unofficial visual language of graffiti and its associated forms have been used to promote fashion labels, music, cars, clubs, sportswear, foodstuffs, drinks and events. Whenever a brand wants to communicate directly with a young audience it can adopt a dialect that suits its particular needs. As well as speaking with the right tone of voice, unofficial visual language is usually inexpensive to produce, adding to its authen-ticity. In truth many of these fail to deliver the authenticity as the context plays such a large part in reading the message. A graphic mark on a cereal box is unlikely to be dangerous and exciting simply because it is on a cereal box. The use of what has come to be known as 'the vernacular' in art and design has been a popular way of adding a layer of perceived authenticity and honesty to a whole range of work. It is often seen as a signal that the marketing department has not been involved in the promotion of a product or service. The vernacular is broadly seen as work which is deliberately undesigned. This draws from a range of visual communication made by amateurs giving it an informal and unofficial flavour. The work is often made by hand or by using instant design systems like plastic peg letters for example.

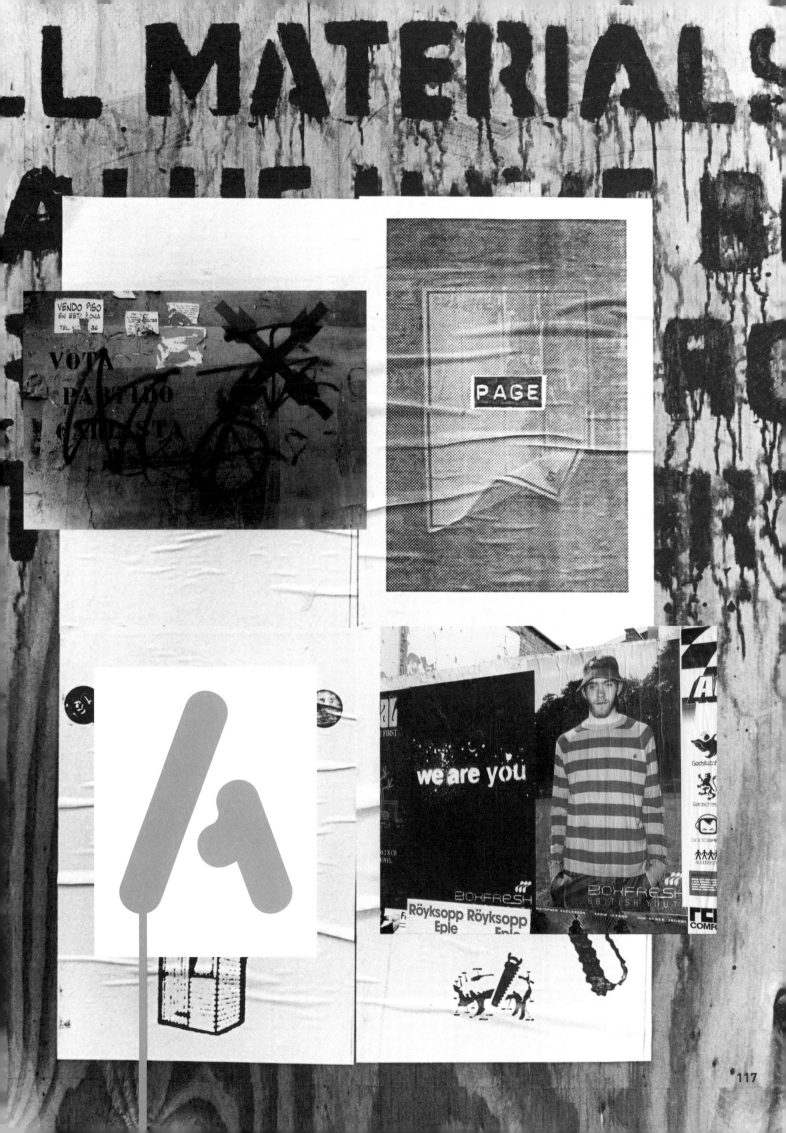

UNDIGNIFIED

Hilton Thompson
Undignified

Unofficial Language and the Visual Arts

A number of the formal values of the vernacular and graffiti can be found in examples of what might be termed 'fine art' e.g. identity, spontaneity, repetition etc. However, few artists have emerged from a background of graffiti with any significant commercial or critical success. The most notable exceptions to this are arguably Keith Haring and Jean-Michel Basquiat. (It must be noted here that both these artists received formal art training unlike the majority of graffiti artists whose work never reaches a gallery.) What is interesting is the extent to which the work revealed its background in graffiti when it was transferred from an unofficial context to the official arena of the gallery. Basquiat who began working as one half of the graffiti team 'Samo' certainly displays in his work the speed and gesture of graffiti:

'...Basquiat was in a terrible and terrifying hurry...drawing for him was something you did rather than some-thing done, an activity rather than a medium... His earliest images on paper show the same authoritative handwriting of his pseudonymous street tags.' [16]

Haring too seemed to recognise the element of performance in making graffiti, 'an activity rather than a medium':

'Haring's commitment to public per-formance was backed by his absolute embrace of chance and spontaneity. He was inspired in equal parts by the automatism inherent in Jackson Pollock's and Mark Tobey's painting process, the assuredness of Oriental calligraphers, and the sheer abandon of graffiti writers "bombing" trains.' [17]

'He did nearly all the subway drawings during the day, often at peak times, and was as intent on sharing the act of art making with his audience as he was on leaving behind lasting art-works in the material sense.' [18]

So already we can see formal similarities between this 'art' and graffiti (speed of

16. Storr R. *Two Hundred Beats Per Min.* (1990) in Robert Miller Gallery's *Basquiat Drawings* (1990)

17. Blinderman B. *And We All Shine On* (1992) in Celant G. *Keith Haring* (1992)

18. Blinderman B. *ibid.*

Basquiat and Haring

execution, spontaneity, drawing materials,
no real distinction between figure and ground,
even context) but also some important
distinctions. The artists' work has been
sanctioned in some way: Basquiat's graffiti
becomes 'drawing' and takes place in a studio
on paper and canvas; Haring works in public
spaces on walls at rush hour without arrest
and often by invitation. Arguably both artists
demonstrate a greater control over the
traditional values of composition, spatial
arrangements of images on a surface and
colour than most graffiti writers, but what
of the subject matter and the issues in the
work? Neither artist was content, as many
writers are, to simply repeat their name.
However, a recurrence of visual symbols
seemed to signal a signature of sorts.

Jean-Michel Basquiat
A Panel of Experts
*James Goodman
Gallery, New York, USA.
©ADAGP, Paris and
DACS London 2003*

Lists of personal heroes
including boxers and
musicians repeated over
the canvas in his trade-
mark handwriting draws
on his background in
graffiti. In this case the
canvas itself is construct-
ed in a casual manner like
a found object from an
urban back street.

Outlaws

Flyers from a boxed
collection of objects.
The box functioned as
a catalogue for an
exhibition which was
staged in a homemade
shed placed outside the
Tate gallery in Liverpool.

With Basquiat it was lists of personal heroes,
boxers, bluesmen and heads, often skulls, to
chant the words, whereas Haring used a
featureless, almost baby-like outline figure
which he coupled with a variety of architectural
or technological objects; the television
screen, steps, flying saucers.

> *Haring's legacy is a model universe, a*
> *lexicon of signs and symbols reflective*
> *of anxiety, euphoria, desire, oppression,*
> *and hope in an age of digital magic*
> *and communications breakdown.'* [19]

There is little to conclude from these
notes other than that perhaps the artists'
background in graffiti is evident in the formal
qualities of the work even if the motives are
less certain. Whether the public considered
the work to be 'art' or 'tactical vandalism'
before it reached the gallery is unknown.
The only thing that seems certain is that once
it appeared in New York galleries it became
'art'. The 'value' of the work was determined
by the other signs which surrounded it. The
work was art because it was placed in an
accepted art gallery.

The UK-based stencil graffiti artist
Banksy has clear views about the essential
difference in placing his work in different
contexts;

> *'...I've done gallery shows and, if*
> *you've been hitting on people with all*
> *sorts of images in all sorts of places,*
> *they're a real step backwards.*
> *Painting the streets means becoming*
> *an actual part of the city. It's not a*
> *spectator sport.'* [20]

Perhaps, as with Carl Andre's 'Bricks' it is
only a matter of one discourse being accepted
into the official discourse over a period of
time. This explanation by an 18-year-old art
student from Blackpool (who was banned
from every railway bridge in Britain in
January 1991 after pleading guilty to seven
charges of criminal damage with spray cans)
seems to sum up the feelings of graffiti
writers and for that reason is worth quoting
in full opposite:

19. Blinderman B. *And
We All Shine On* (1992)
in Celant G. *Keith Haring*
(1992)

20. Banksy in Manco T.
Stencil Graffiti (2002)

21. *The Guardian* 21st
January 1991 4.1.3
interview

'It's a good feeling – like being an outlaw. Out there in the night with a couple of friends on your own. You're creating something wonderful and beautiful for others to enjoy. I understand that British Rail don't want to see murals on their walls, but I don't look upon it as vandalism. It's popular art. Unfortunately a majority of people are ill-informed and don't understand what the culture is about. It's about self-expression. We are adding something colourful to a blank, bland surface which others will see and admire. It may not be fully appreciated at the moment, but in due course I believe it will be recognised as an art form.' [21]

Burn
Wastebin
unofficial language

Design group Burn use
the visual dialect of graffiti
and vandalism as part of
their self-promotional
work.

Ian Wright
**Skip MacDonald
(Tackhead)**
dialect

A reprocessed photograph of the musician is fed repeatedly through a single colour copier, changing the colour cartridges before each pass.
The result is a gritty low-tech portrait with the visual attitude of low-cost flyposters and fanzines.

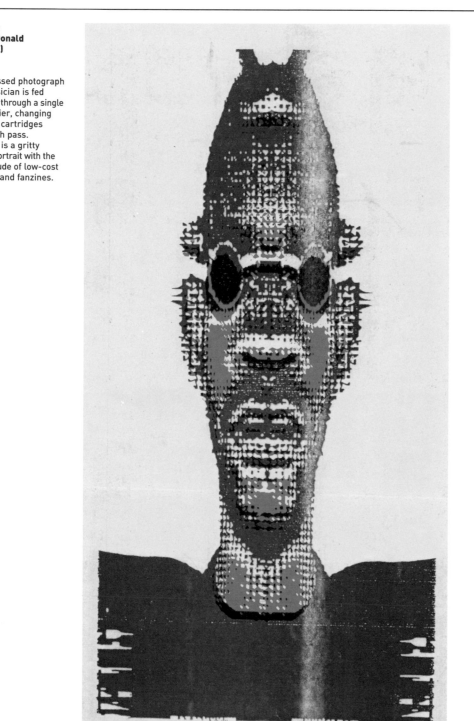

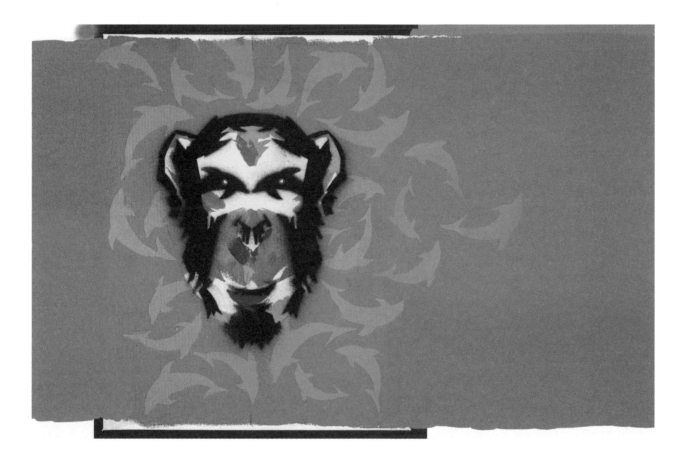

Ian Wright
Ian Brown
Dolphins were Monkeys
dialect

Hand-painted marks and
sprayed stencils use the
media of graffiti to illustrate
the cover for Ian Brown's
record. The images come
loaded with the second-
order signifiers associated
with graffiti; the danger,
excitement and authenticity
of street culture.

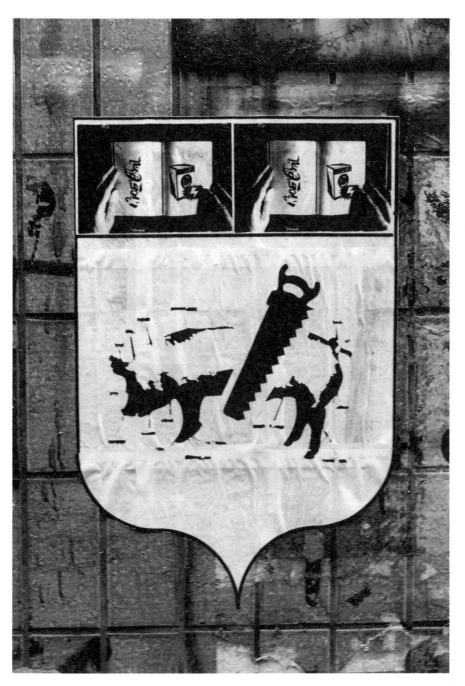

David Crow
Trouble
dialect

A selection from a series of posters displayed on walls in the city of Salford, England. The aim of the project was to use the semiotics of urban situations to engage passers-by in a visual dialogue about 'territory'. The semiotics of street posters could be described as a visual *dialect* as it speaks directly to a distinct community. In many cases the posters were destroyed and it was clear that the presence of paper and ink was enough to render the posters part of an 'official' visual culture which was directly at odds with what normally happened in these spaces.

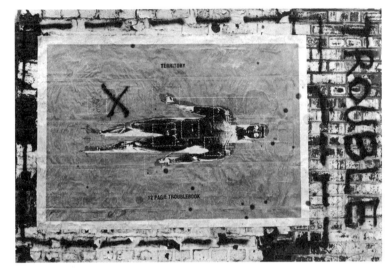

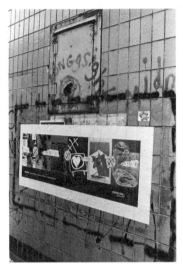

1 & 2.
Alan The Barber and
Gerry The Fridge Man
unofficial language

Authentic vernacular lettering on city shop-fronts which is often used as a source of inspiration for designers who want to remove the veneer of formal design qualities from their messages.

3. Alan Murphy
Loud Words
unofficial language

Vernacular lettering and handwriting is used to communicate a distinctive personality in this highly personal composition.

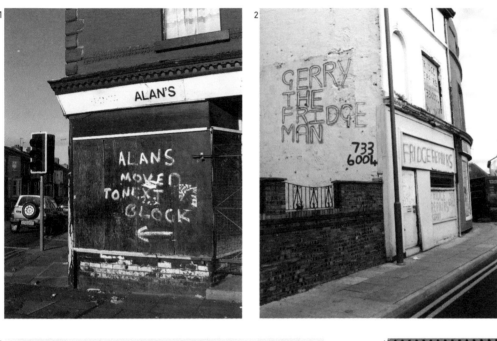

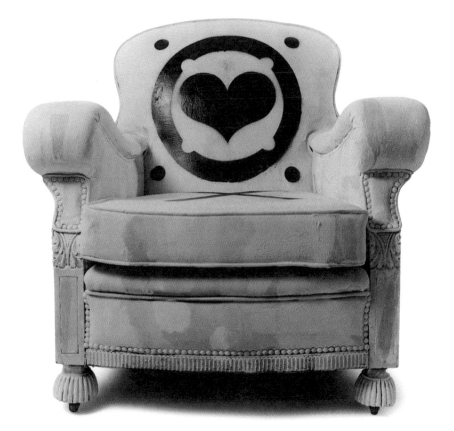

4. Ian Wright
Business Card
unofficial language

Menu board lettering
is used to downplay
the formality of an
illustrators' business
card. This visual dialect is
carried through by using
utility packing cardboard
and misregistered print.
The text supports this
impression by using the
everyday description
'Painter & Decorator'
and relegating the word
'Illustration' to the
background.

5. David Crow
and Guy Hawkins
Love .net
unofficial language

A discarded chair is used
as the basis of a sculptural
corporate identity for a
recording label.

5

LOVE **.net**

1st floor, Ducie House, 37 Ducie Street, Manchester M1 2JW
Tel 0161 236 0457 Fax 0161 236 0261 E-Mail razz@lovenet.u-net.com

with compliments

symbolic creativity

7. symbolic creativity

1. Willis P. *Common Culture* (1990)

'The multitude of ways in which young people use, humanise, decorate and invest with meaning their common and immediate life spaces and social practices – personal styles and choice of clothes; selective and active use of music, TV, magazines; decoration of bedrooms; the rituals of romance and subcultural styles; the style, the banter and drama of friendship groups; music-making and dance.' [1]

James Jarvis
Above – **Ozzy**
Opposite – **In My Room**

Illustrations originally produced for 'The Face' magazine.

Paul Willis [2] introduces us to the idea of 'symbolic creativity' by quoting statistics from the 'General Household Survey' in the UK [3] and it may be useful to repeat some of those figures here; 4% of the population attend museums or art galleries, 90% watch television for over 25 hours per week, 2% of young people (20–24yrs) attend the theatre (the most popular single British arts venue), 92% of young people listen to radio and 87% buy records or tapes.

These figures support Willis' assertion that the various genres which constitute high art are currently institutions of exclusion which have no real relationship to young people and their lives. He continues by arguing that the arts establishment has done little to discourage the commonly held belief that gallery-based art is special, heightened, and certainly not everyday. He goes further to say that in fact these institutions of high art promote a fear of cultural decay in order to strengthen claims for subsidy and privilege. Against this Willis claims there is a vibrant 'symbolic life' and an active 'symbolic creativity' in everyday life, everyday activities and expressions. He points us to the way in which young people's lives are actually full of expressions, signs and symbols despite their not being involved with the arts. Willis states:

> '...the multitude of ways in which young people use, humanise, decorate and invest with meaning their common and immediate life spaces and social practices – personal styles and choice of clothes: selective and active use of music, TV, magazines; decoration of bedrooms; the rituals of romance and subcultural styles; the style, the banter and drama of friendship groups; music-making and dance.' [4]

It is this ability of high art to distance itself from these things, insisting on a prior educational knowledge which leads to a complete dislocation of art from living contexts resulting in what Willis calls 'hyperinstitutionalisation'. This is explained as a situation where formal features become the guarantee of an aesthetic rather than a relevance to real life concerns. The people who don't understand, the uncultured, simply lack the code and are seen (or may even see themselves) as ignorant or

Willis claims there is a vibrant 'symbolic life' and an active 'symbolic creativity' in everyday life, everyday activities and expressions. He points us to the way in which young people's lives are actually full of expressions, signs and symbols.

2. Willis P. *Common Culture* (1990)

3. *The General Household Survey* (1983–6) (Cultural Trends p. 51)

4. Willis P. *ibid.*

5. Willis P. *ibid.*

play

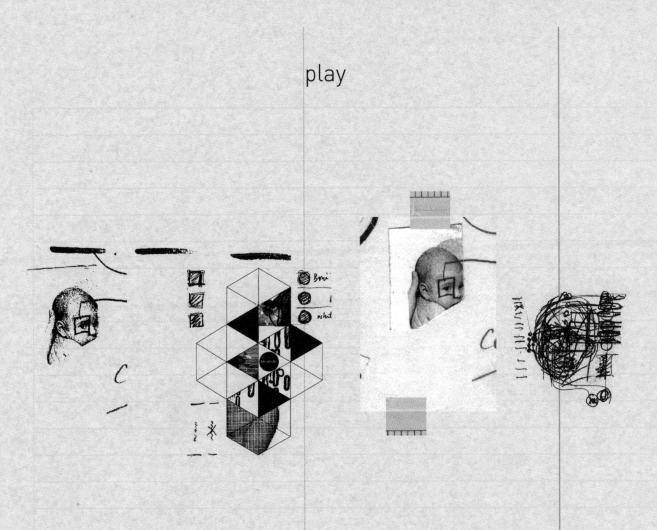

insensitive. He also returns to Bourdieu's notion of fields by placing the subsidised artist on the periphery of the 'field of symbolic creativity' rather than at the centre, reversing the traditional view by placing the public at the centre. Willis maintains that this symbolic activity is not only vibrant but necessary as human beings are communicating as well as producing beings, furthermore whilst all are not productive, all are communicative. He stresses that the necessity of 'symbolic work' has been forgotten and offers us a definition:

> 'The application of human capacities to and through, on and with symbolic resources and raw materials (collections of signs and symbols – for instance the language as we inherit it, texts, images, films, songs, artifacts to produce meaning).' [5]

This is somewhat at odds with the English radical tradition of the 1920s and 1930s which followed the ideas of people like William Morris who stressed the dignity of labour expressed in Morris's equation; art = work/pleasure. Necessary work was at this point seen as human capacities applied through the action of tools on raw materials to produce goods or services (usually through wage labour). However, Willis points out that the mechanisation of modern industry has made it impossible to find art in paid work and points to an extreme example where a study of British factory workers found more opportunity for symbolic production in driving to work than there was to be found at work. This lack of opportunity for necessary symbolic work in the workplace highlights the importance of 'play' in our individual expression. It is then the 'informal' rather than the 'formal' situation which offers us

David Crow
Megafamily

Sketches and development work from 'Megafamily' font featured on page 139.

This is how we produce and reproduce our own individual identities, who we are now and who we could become. It also places these identities in time/place and defines membership of groups such as race, gender, age, region.

freedom and choice in symbolic activity and increasingly this is where our necessary symbolic work takes place. According to Willis this increased importance on play has been reflected in the huge growth of commercialised 'leisure' with opinion divided about whether commercial status devalues cultural currency.

Willis separates symbolic creativity from material production and suggests it be seen as symbolic production. He outlines four elements needed for necessary symbolic work;

> 1. The primary communication tool of language which enables interaction and allows us to assess our impact on others and their impact on us.

> 2. The active body (according to Willis this is the site of signs and symbols).

> 3. The drama of roles and rituals which we perform with others.

> 4. The practice of symbolic production (where language is both the raw materials and the tools) bringing about new ways of producing meaning.

Willis maintains this is intrinsically attached to energy, feelings, excitement and psychic movement. He believes this to be the basis of confidence.

Having outlined what symbolic creativity is and what we need in order for it to take place,

Willis then offers a number of examples of what is produced by symbolic creativity. He suggests that this is how we produce and reproduce our own individual identities, who we are now and who we could become. It also places these identities in time/place and defines membership of groups such as race, gender, age, region. It also empowers us with the expectation of being able to change the world we live in, to make our mark so to speak. It is worth noting here that Willis sees these activities as 'transitive' in that we are constantly experimenting with these expressions of identity and have a cultural sense of which haircut, language, clothes, music etc. works most economically for ourselves. Willis stresses the importance

'In many ways this is a question of cultural survival for many young people.' [6]

6. Willis P. *Common Culture* (1990)

7. Marsh P. and Rosser E. and Harré R. *The Rules of Disorder* (1978)

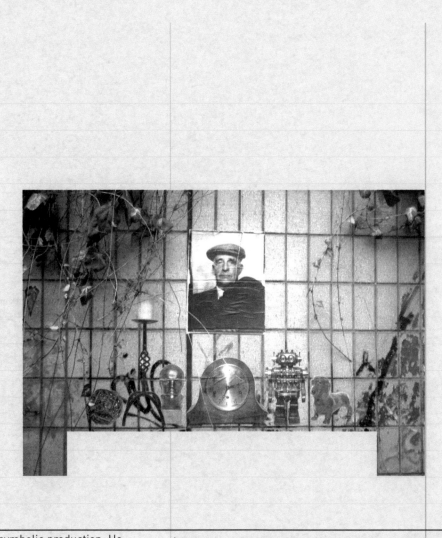

of this aspect of symbolic production. He points out how young people in particular feel marginalised by the constructed visions of 'youth' supplied by our society through institutions, advertising, magazines and television. This is brought about by the perception of a clear difference between how they are told they should be and how they actually are. Studies of football hooligans in the UK also point to the necessity for disenfranchised young people to define their identity in opposition to existing constructs.

'The struggle begins when they see many of the things that seem routine to the rest of us as ways of devaluing them...If they are to have any significance, their lives must be self-constructed and made significant with the use of home-made materials.' [7]

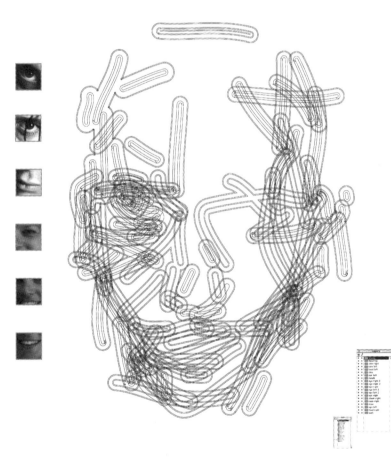

David Crow
Megafamily
play

Font designed for 'Fuse'
magazine Genetics issue
No. 13. The brief was to
consider the genetic
growth of typography.
The resulting font is a
typographic game which
holds fragments of a
female portrait on the
upper-case keys and a
male portrait on the
lower-case keys.
By typing between the two
sets the player can create
thumbnail portraits of
possible offspring.
The underlying theme is
the drift of typography
from the economic world
to leisure.

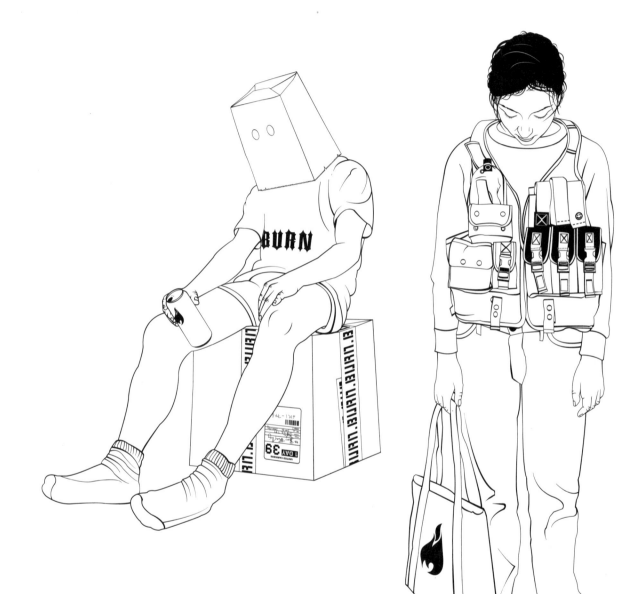

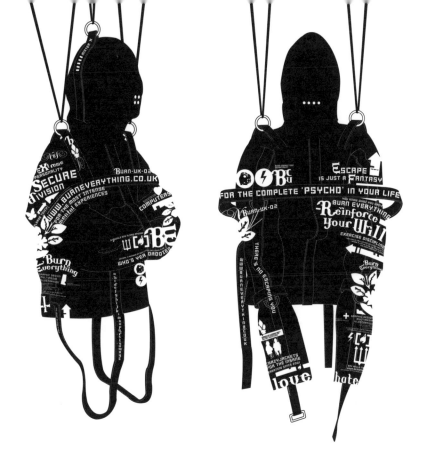

Burn
**baghead, thatgirl,
straightjackets,
burntruck**
symbolic creativity

Personal lifestyles, choice
of clothes, selective use
of music, eccentric visual
imagery and subcultural
styles are all part of the
way that design group
Burn describe their
identity in a range of self-
promotional work which
deliberately steers
away from conventional
corporate identity.

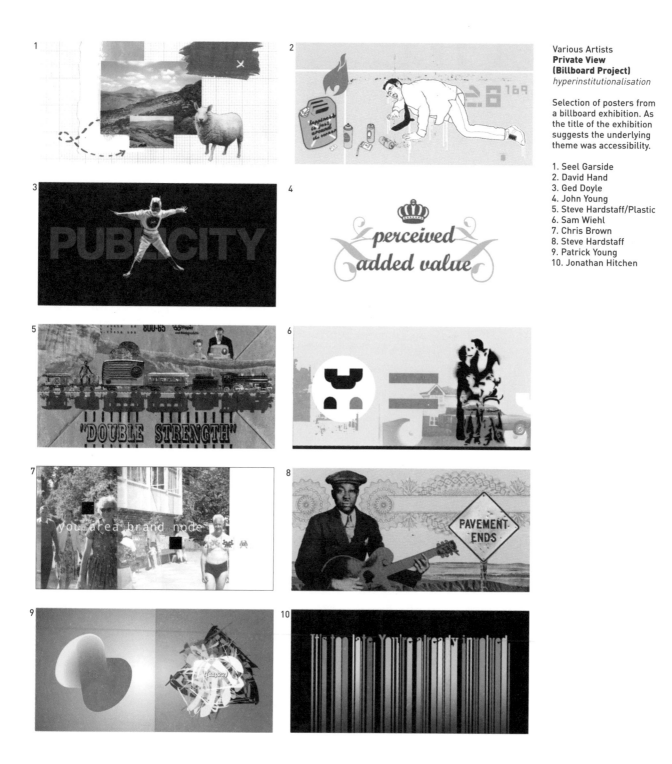

Various Artists
**Private View
(Billboard Project)**
hyperinstitutionalisation

Selection of posters from
a billboard exhibition. As
the title of the exhibition
suggests the underlying
theme was accessibility.

1. Seel Garside
2. David Hand
3. Ged Doyle
4. John Young
5. Steve Hardstaff/Plastic
6. Sam Wiehl
7. Chris Brown
8. Steve Hardstaff
9. Patrick Young
10. Jonathan Hitchen

1. Ian Wright
2. Marion Deuchars
**Wardrobes for Howies
Clothing**
symbolic creativity

Two customised
wardrobes from a series
for Howies, a small ethical
skate and bike clothing
company based in the UK.
The idea of using aban-
doned wardrobes comes
from the way that skaters
break old furniture to use
as skateboard ramps. A
point-of-sale idea which
has grown directly from
the skater's creative use
of found materials.

Illustrators
Ian Wright
Marion Deuchars
Creative Director
Phil Carter
Design Consultancy
Carter Wong Tomlin

junk and culture

8. junk and culture

Mary Douglas points out that dirt is the by-product of a system of order. Dirt has been rejected in a process of classification as the elements which are out of place. She argues that if we look at what counts as dirt then we can begin to understand and identify the system which rejected it.

1. Douglas M. *Purity and Danger* (1966)

2. Douglas M. *ibid.*

dirt and taboo

Dirt and Taboo

Our ideas about what constitutes dirt are part of a symbolic system of signs which has clear categories, used to organise the signs into a hierarchy of importance or use.

'Shoes are not dirty in themselves, but it is dirty to place them on the dining table. Food is not dirty in itself, but it is dirty to leave cooking utensils in the bedroom, or food bespattered on clothing; similarly bathroom equipment in the drawing room; clothing lying on chairs; outdoor things indoors; upstairs things downstairs; underclothing where overclothing should be and so on. In short, our pollution behaviour is the reaction which condemns any object or idea likely to confuse or contradict cherished classifications.' [1]

'Where there is dirt there is a system.' [2]

disorder

Douglas shows us that the threat of danger is often used as a justification of social convention. We might well be endangering our health or that of our family by not throwing out an item of chipped crockery. Dangerous germs may lurk in the 'chip', ready to make us ill. She points out that what is really under threat is the semiotics of ordered social convention which are the agreed practice in our society.

To understand why something has been rejected we need to rebuild a picture of the systems of signification which lie beneath the decision to reject it from the system. In this sense then we can see that the study of dirt or rubbish is a semiotic study.

For example, to understand what is currently fashionable in typography or painting you would need to look at what has been discarded as unfashionable. This helps to define the category and describes for us what is at the margins of acceptance into this 'fashionable' category.

In chapters 5 and 6 we looked at the idea of **official** and **unofficial language**. We have also discussed the interplay between the two – one cannot exist without the other. In order to understand what constitutes legitimate language we need an understanding of what has been rejected as inappropriate in any given situation. Unofficial language is the 'dirt' in the system of language which has been edited out in favour of an accepted legitimate usage.

86

▼

rubbish theory

'As we know it, dirt is essentially disorder.' [3]

Since order and pattern are made from a limited selection of elements, there is then an implication that pattern is restricted in some way. Disorder, the enemy of pattern, could then be considered unlimited. Disorder has no pattern in itself but its potential for making pattern is infinite. Douglas argues that we recognise firstly that disorder destroys existing patterns but also that it has a huge potential. This leads us to view disorder as a symbol of both danger and power.

Rubbish Theory

In his essay 'Rubbish Theory', Jonathan Culler [4] invites us to consider the rubbish which is not particularly dirty, nor is it taboo. This is the rubbish which we all have stored away in spare rooms, garages and lofts. Old football programmes, comics, postcards, tickets, coins etc. Some of this is rubbish which we have inherited; my father's pen and a watch that doesn't work; my grandfather's penknife and ration book from the 1940s were all edited from a wider set of rubbish where some things were kept and others rejected. If dirt is evidence of a system of classification then just how, asks Culler, do we read these cupboards full of everyday rubbish?

3. Douglas M. *Purity and Danger* (1966)

4. Culler J. *Rubbish Theory* (1988) in Culler J. *Framing the Sign* (1988)

transient and durable objects

Much of this material functions as souvenirs in some way. Perhaps it signifies for us an experience we have had, or something we have seen, which in time will become a significant part of our life. In visual constructions which use these sort of items they are often used to signify memory in some way. You may find it disrespectful to consider mementos, especially those handed down by your parents, as rubbish. However, in most cases the collected material has no economic value nor in most cases, any practical use. For these reasons we can consider it rubbish. This relationship between rubbish and value is clarified by Michael Thompson in his essay 'Rubbish Theory'. [5] Thompson identifies three semiotic categories of objects which have a direct relation to economic value, these categories will be explained over the following pages.

Transient Cultural Objects

These are objects which have a finite life span and their economic value decreases over time.

Foodstuffs are an obvious example of transient objects but the term could also refer to objects which are susceptible to the whims of fashion. This illustrates that it is not only the physical properties of the object which categorise it, but there is also a social dimension which attributes value based on the values in our society.

Durable Cultural Objects

These are objects whose value is maintained or even increased over time. They have no finite time-span, they may even be considered as having an infinite time-span. Antiques are a good example of durable objects. This category would also include items which may have started life as fairly inexpensive and common items but have become considered durables because there is a collectors marketplace for these objects. Certain recordings for example have more value now than they did when new, or a commemorative item from an historical event e.g. a keyring from the Queen's Coronation. In brand advertising many objects are presented in a way which reinforces their durable qualities. Mercedes Benz, Jaguar and Rolex are all brands whose products are deliberately bound up in the notion of durable objects.

The Mercedes Benz motor car is an example of what we would describe as a 'durable object' whose value is maintained or, in some cases. increased over a period of time.

5. Thompson M. *Rubbish Theory: the Creation and Destruction of Value* (1979) in Culler J. *Framing the Sign* (1988)

rubbish

Thompson [6] points out that those who have wealth or power will strive to keep their durable objects in that category and ensure that the transient objects of others remain so. This is a necessary step as we know it is possible for objects to shift from one category to the other and the transfer of economic value follows this shift. To explain how this change is possible Thompson identifies a third category which is less obvious to us.

Rubbish

This category contains objects which have 'zero and unchanging value'. Thompson outlines a scenario where the transient object gradually loses value until it is worthless. It remains in this valueless state until someone rediscovers it and transforms it into a durable object. We have all experienced revivalist fashion which has been born from an utterly unfashionable period. The styles which have only recently waned in popularity rarely make a successful comeback whereas a style which has been discarded always has the potential for being very fashionable again.

Thompson's 'Rubbish Theory' [7] describes how transient cultural objects can only move to the durable category once they have been considered rubbish. Buying a classic car or a piece of antique furniture rather than a new model is about buying into the semiotic idea of durable objects. The way we treat our objects is also a sign of which category we believe they belong in. We might cherish and maintain our classic car, carefully restoring the most banal detail to its original state. However, if we have a new model which declines in value, at some point we are likely to let things go wrong as we plan to replace it shortly. It is simply not worth any more investment. We may eventually pay a scrap metal dealer to tow away our worthless vehicle where it sits in a yard untouched for years only to discover two or three decades later that it is now considered a classic and our old car has been bought by a collector for restoration.

This theory appears to draw inspiration from 'Purity and Danger' [8] where Mary Douglas poses the question of whether dirt, which is normally destructive, can ever be

This category contains objects which have 'zero and unchanging value'.

6. Thompson M. *Rubbish Theory: the Creation and Destruction of Value* (1979) in Culler J. *Framing the Sign* (1988)

7. Thompson M. *ibid.*

8. Douglas M. *Purity and Danger* (1966)

MasterluxTheBaptist

David Crow
Masterlux The Baptist

Signs from Christian
religion are mixed with
consumerist signs as
part of a series of screen
prints which present
shopping as a new
religion.

considered creative. In her exploration of this
question she describes two stages that dirt
must go through to achieve creative symbolism.
Firstly, in the process of imposing order, dirt
must be differentiated as being out of place.
Dirt is seen to be unwanted but it still has
some identity at this stage in that it can be
recognised as the unwanted item. Over time,
however, this identity gradually disappears
until the unwanted item becomes part of the
general mass of rubbish.

> 'Earth should be a cloud of dust, a soil
> of bones,
> With no room even for our skeletons.
> It is wasted time to think of it, to count
> its grains,
> When all are alike and there is no
> difference in them.'[9]

Douglas states that as long as there is no
identity then dirt is not dangerous. At this
stage it is not differentiated in any way just as
it was before it became classified as dirt.
This completes a cycle where dirt moves from
a non-differentiated state to a differentiated
state (recognised and classified as dirt) then
finally back to its original state of non-
differentiation as part of the general mass of
discarded dirt. She argues that it is in this
formless state that it can function as a sign
of growth as much as a sign of decay. The
argument concludes that everything that applies
to the purifying role of water in religious
symbolism, could also be applied to dirt.

9. Sitwell S.
Agamemnon's Tomb
(1972) in Douglas M.
Purity and Danger
(1966)

10. Culler J. 'Rubbish
Theory' in Culler J.
Framing the Sign (1988)

the use of rubbish in the visual arts

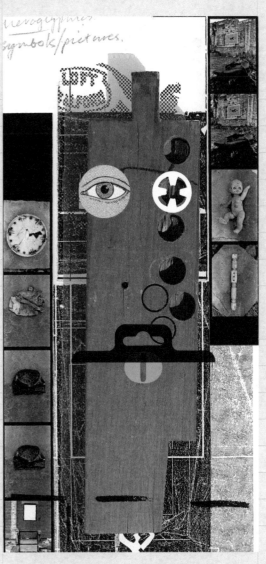

The Use of Rubbish in the Visual Arts

As we have already seen in chapter 5 **official language** there are clear hierarchies at play in cultural production. The Fine Arts are generally considered as a more significant practice than the design disciplines. The artefacts produced by each of these areas are also considered differently in terms of their importance as cultural objects. In his essay, 'Rubbish Theory', Jonathan Culler [10] describes two types of cultural artefact. Firstly, there are artefacts which are part of the practical world, utilitarian objects **86** or information such as newspapers, ▼ magazines and television. These are considered transient cultural objects.

A debate often ensues where those who wish to establish the object as a durable draw on the discourse of legitimate language to justify the transition.

priceless
worthless

Then there are artefacts which have no obvious purpose and are presented as being separate from commercial or practical concerns.

These are part of our world of leisure and are broadly categorised as part of our cultural heritage. These we see as durables. Culler points out that cultural rubbish has become a valuable resource in the visual arts. He cites the example of Carl Andre's 'Bricks' bought by the Tate Gallery in 1972. This pile of common household bricks would be considered rubbish by many who saw it at the time. They may well have a similar pile of unwanted bricks in their own backyard. However, the museum who bought the work saw it as part of the category of durables. The work had been 'authorised' by the museum

and arrangements of common rubbish made by recognised artists became collectable again. A marketplace for similar artefacts had been established and the 'Bricks' increased in value. More recently the same gallery came under fire from the popular press over the display of Tracey Emin's 'Bed', surrounded by an assortment of household rubbish. Although there is little concern shown when transient objects become rubbish, the transformation from rubbish to durable always provokes a strong reaction. A debate often ensues where those who wish to establish the object as a durable draw on the discourse of legitimate language to justify the transition.

There are a number of earlier examples of

The transient object gradually loses value until it is worthless. It remains in this valueless state until someone rediscovers it and transforms it into a durable object.

this transition in the visual arts where an equally vociferous outcry heralded their appearance. If we look at the self-proclaimed anti-art Dada movement there are numerous examples of works which used rubbish as a resource to change the way we approach the notion of what constitutes a work of art. Marcel DuChamp's sculptures from the early part of the 20th century such as the 'Bicycle Wheel', the 'Hat Rack' or the 'Urinal' were all discarded functional objects which became durables and are now cited as classic pieces of art, serving as inspiration for generations of visual artists.

Ian Wright
Issey Miyake Store
Dog Tag and **Ghost Gorilla**
transient to durable

Dog Tag and Ghost Gorilla
created for the Tribeca
branch of Issey Miyake
which functions as a store
and a gallery. Dog Tag
was made from luggage
labels and Ghost Gorilla
from paper drinking cups.
Each was made from
children's beads in the
first instance as a 'rough'
and then transferred
directly on to the wall.

Ian Wright
Mr Rizla
Crayon Head
transient to durable

Both the portrait of
Mr Rizla and the Crayon
Head for the cover of
'Creative Review'
magazine make use of
low value transient
cultural objects. These
objects are transformed to
durable objects once they
have been reassembled
as art.

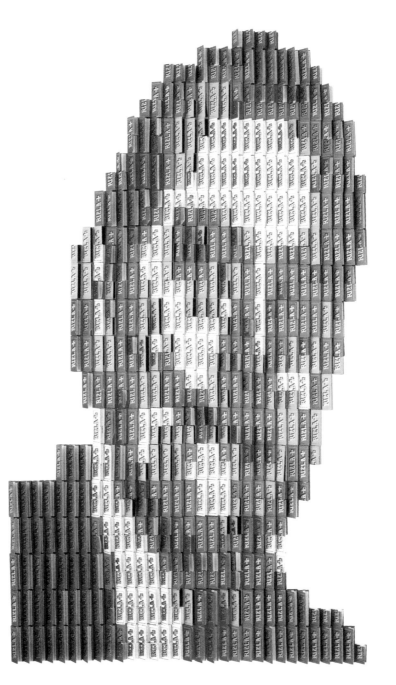

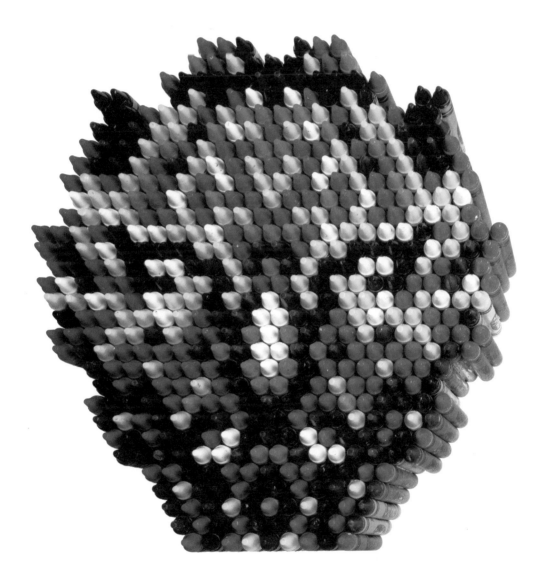

Russell Mills
**Nine Inch Nails
Closure**
rubbish to durable

Front cover of the slipcase
for the second of two
videos for a double live
video package.
Mixed-media assemblage
using plaster, acrylics,
oils, wax, bronze powders,
pigments, graphite, mica,
insects, plastic netting
and rusted fence wire on
wooden panel. This piece
shows a series of 'wounds'
and traces of scars made
in textural beds.

Russell Mills with
Michael Webster
Republic of Thorns
rubbish to durable

Left – Cover image from
the catalogue for the
installation 'Republic of
Thorns'. The installation
was commissioned by the
Wordsworth Trust as the
inaugural event for the
Trust's newly created 3
Degrees West Gallery,
Grasmere, Cumbria.
The installation was
created by Russell Mills,
Ian Walton and Poet in
Residence Paul Farley.

A still from a film of
feathers in ceaseless
turmoil, trying to escape
earthly bounds echoing
Wordsworthian impera-
tives, it is meant to suggest
an aspirational mindset.

Right – Back cover of a
four-panel CD digipak
made as the catalogue for
the installation 'Republic
of Thorns' showing the
main focal point of the
installation, a staircase
of earth-clad books rising
from a floor of broken
glass to disappear
through the ceiling.

Russell Mills
**Nine Inch Nails
Closure**
rubbish to durable

Front cover of the slipcase
for one of two videos for
the double live video
package.
Mixed-media assemblage
using plaster, acrylics,
oils, wax, honeycomb
fragment, cotton thread
and a fishing fly on a
wooden panel. A fragment
of golden honeycomb
penetrates and splits
apart an earth-red band
of plaster.

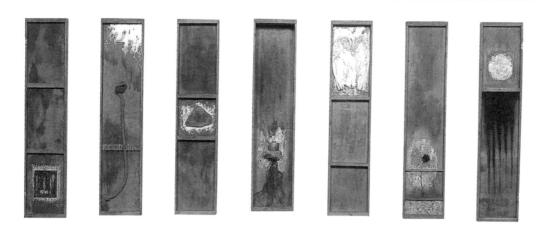

Russell Mills
**Those Who Don't Know
What To Do, Do What
They Know**
rubbish to durable

Seven wooden trays each
87x19cm. Spray paints,
ash, gold leaf, copper
wires, inkpot fused into
rock, tree roots, stone,
carbon, bird's wings, coal
dust, lady's vanity case,
salt, rope, sand. Mixed-
media work which is
concerned with notions of
optimism and aspiration
countered by parochialism,
timidity and cultural
xenophobia. The seven
shallow trays originally
formed a joiner's tool box
which were designed to be
stacked atop one another
within a larger chest.

open work

9

9. **open work**

1. Eco U. *The Open Work*
(1989) (first published
1962)

2. **Zeman** J. *Peirce's
Theory of Signs* (1977) in
Sebeok T. *A Profusion of
Signs* (1977)

3. Eco U. *The Role of the
Reader* (1981)

The term 'The Open Work' comes from the book of the same name [1] written by Umberto Eco, a philosopher and semiotician born in Piedmont, Italy in 1932. The work was first published in 1962 and remains a significant piece of writing today as it anticipated important developments in contemporary art. In particular Eco is interested in the relationship between the author of a work of art and the reader.

Like Peirce [2] before him he places particular emphasis on the role of the reader as an important part of the creative process. As readers we receive a work of art as the end product of an intended message. This message has been assembled and organised by the author in a way that makes it possible for the reader to reassemble it for themselves as the author intended. However, we know that the background of the reader affects the way that the message is reassembled.

The overall meaning of the message may be constant but each of us brings an individual perspective to the reading based on our culture, background and experiences. Eco prefers the notion of 'encyclopedia' to describe the transfer of meaning through the use of signs than the more common term 'code'. For Eco a code implies a one-to-one transfer of meaning like a dictionary definition, whereas encyclopedia suggests there are a number of interpretations which are interrelated and the reader must negotiate their own path through the network of possibilities. Although Eco sees an openness in the reading of signs he does not, however, suggest that there is an infinite number of readings. Rather he describes a situation where the work of art is addressed to an ideal reader who will select from the suggested readings of the work.

The ideal reader is not so much a perfect reader who interprets the work exactly as the author intended but as a reader who is awake to the possibilities that the work contains.

Eco sees each work of art as a performance [3] as it takes on a new interpretation

information and meaning

$$\text{information} = \log \frac{\text{odds that the addressee will know content of message } \textit{after} \text{ receiving it}}{\text{odds that the addressee will know content of message } \textit{before} \text{ receiving it}}$$

If a newsflash tells me that tomorrow the sun will rise, I have been given very little information as I could have worked this out for myself.

If however the newsflash tells me that the sun will not rise then I have a lot of information as this is a highly improbable event.

each time it is received or read. Much of his writing focuses on musical performances as an example of the open work. Composers such as Stockhausen are cited as examples as the work is open in a more obvious way than in the visual arts. The composer supplies the musician with a kit of parts with an invitation to interpret the material for themselves.

In this way the work is obviously incomplete until the reader is involved. The freedom on the part of the reader, in this case the musician, is conscious and explicit. Indeed in asking the musician to interpret the work in their own way the artist also invites us to ask why they want to work in this way. What is the conceptual framework for the work?

In the visual arts there has been a shift towards a greater personal involvement on the part of the reader. Along with a greater degree of formal innovation has come a greater degree of ambiguity. When Eco published 'The Open Work' the art world was dominated by developments such as abstract expressionism and action painting, movements which questioned our traditional views on representation and meaning, which called for a the reader to work harder to find the meaning.

Information and Meaning

In an attempt to help define what he means by openness, Eco is interested in using the mathematical science of information theory to measure the relationship between the amount of information that the reader receives and the openness of a work. It is important to note that he sees information to be a different thing to meaning or message. He suggests that the amount of information contained in a message is dependent on the probability of the reader already knowing the content of the message before it is received. If a newsflash tells me that tomorrow the sun will rise, I have been given very little information as I could have worked this out for myself. If, however, the newsflash tells me that the sun will not rise then I have a lot of information as this is a highly improbable event. Eco presents a mathematical formula, reproduced here for reference, which essentially proposes that the amount of information contained in a message is inversely proportional to the probability or predictability of the message. This is of particular interest to Eco as contemporary art is highly unpredictable because it often dismisses the established

DON'T

The amount of information contained in a message depends on

BELIEVE

where it originates and on its probability.

A WORD

semiotic conventions and rules which preceded it. Eco argues that contemporary art contains much higher amounts of information, though not necessarily more meaning, by virtue of its radical nature. More conventional forms of communication, the road sign for example or figurative painting, may carry more distinct meaning but much less information.

He also points out that the amount of information contained in a message is affected by another factor, our confidence in the source of the message. The example he uses is the traditional Western Christmas card. A seasonal greeting sent each year between families and friends. To receive a Christmas card from the secret police would be a very different proposition to receiving a card from a favourite aunt. Although the message is essentially the same (Merry Christmas) the amount of information varies hugely because of the improbability of the source. Similarly if my landlord were to tell me the apartment had damp problems before I rented it I would be more inclined to believe him as he has nothing to gain by fabricating this message. It is tempting to assume that information and meaning are the same thing. However, we can see from this example that the amount of information is greater where the source is improbable. Compare this to the statement; 'Christmas is an annual festival'. This has a very clear and direct meaning with no ambiguity, yet it doesn't add to our existing knowledge. In other words the amount of information is low despite the communicative value being high.

Openness and the Visual Arts

Eco focuses on the abstract painting styles of abstract expressionism and action painting, which were current when 'The Open Work' was written. He describes how these can be seen on one level as the latest in a series of experiments to introduce movement into painting. However, there are a number of ways in which movement is signified in the visual arts. The use of repetition or the addition of trace lines around an image have long been established as signifiers of movement. These are signs that work on fixed structures and have been around for as long as we have used images to communicate. In these cases the nature of the sign itself is not affected, merely the position of the signs relative to each other. For example, if we repeat the same figure a number of times across the same work in different settings then we begin to describe a timeline and we see the figure in a changing narrative. Compare this with the ambiguous forms of the Impressionist painters, the blurred images that became possible with the introduction of the camera or the gestural marks of abstract expressionism. In these examples the nature of the sign itself has become ambiguous if not the forms they signify. We still read the forms in the paintings as people or buildings or bridges but according to Eco, they have acquired an inner vibrancy. The reader is now conscious of the movement of light around the subjects. Similarly with the gestural marks of abstract expressionism we are reading the way the

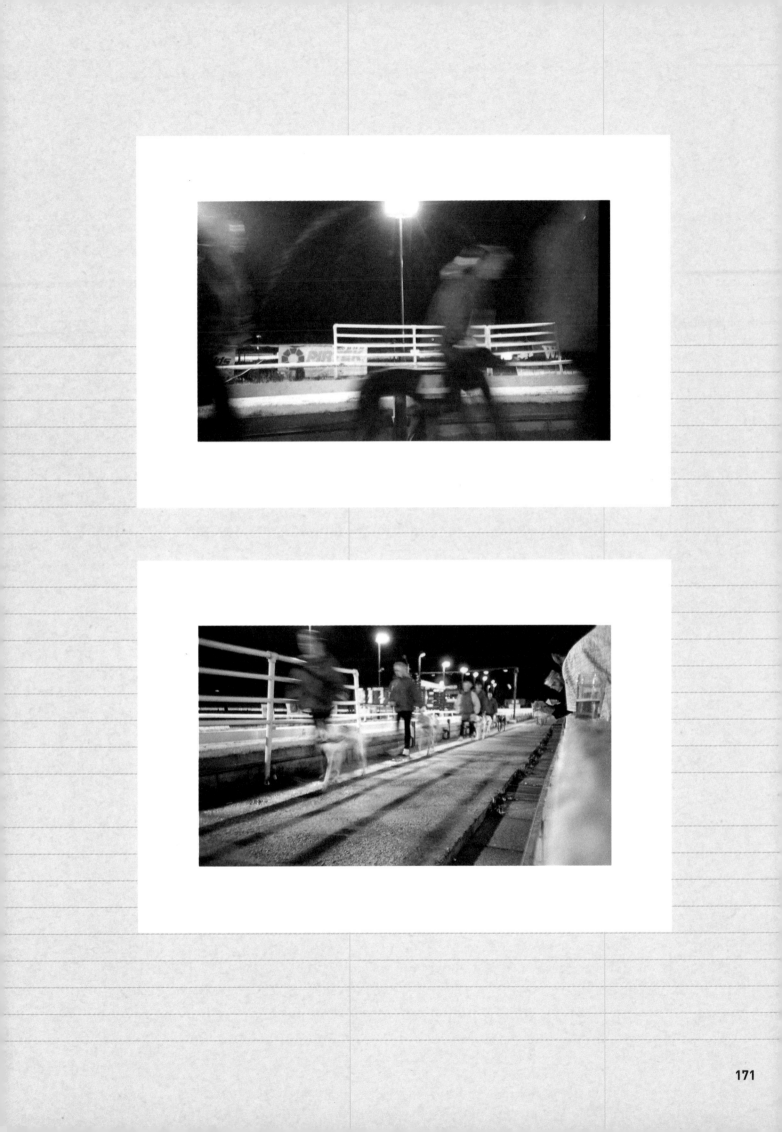

mark is made, the action which has left this mark as evidence. The open work offers the reader a field of open possibilities. They can choose their own viewpoint, decide for themselves what is foreground and background and make their own connections between different parts of what they see.

An obvious example of this might be the sculptural mobiles of artists like Alexander Calder, that theoretically offer the possibility that no two experiences of the work will be the same.

The question one invariably asks of work like this is whether or not it communicates. Is the work legible and how do we stop it descending into a chaotic visual noise or a complete communicative silence?

Openness and Information

Eco is interested in the tension between the information offered to the reader and the necessary amount of legibility and comprehensibility to allow the work to be interpreted. Can the reader detect the intentions of the author of the work? Is an agreement between the two discernible?

Some types of visual communication clearly need structure and order; signs which because of their practical application need to be read and understood quickly. In situations where speed of communication is important, pictograms bridge the gap between the technical world and language. In other cases where the practical application is less important there are signs which merely seek

Ian Wright
Heads

 The skull and
crossbones is a
symbol which
because of its
practical application
(i.e. on poisonous chemi-
cals, electric pylons etc.)
needs to be read and
understood quickly.
In situations where speed
of communication is
important these picto-
grams bridge the gap
between the technical
world and language.
The heads by Ian
Wright work on a
quite different
level; in this instance
the reader is invited to
bring their own meaning
and character to the
drawings.

to give information as opposed to meaning.
Another way of looking at these signs is to
see them as seeking to deliver not a single
meaning but an abundance of possible mean-
ings. In contemporary art and design there
are many examples of work that deliberately
seek to avoid what Eco calls 'the laws of
probability that govern common language'. 4
In fact he points out that contemporary art
draws its value from this deviation from
common structures.
 If we spill ink on a blank sheet of paper
we are presented with a random image which
has no order. No particular direction is given
to the reader in terms of how to interpret the
image. If we then fold the paper in two and
transfer the image onto both sides of the paper
we now have an image with some order.

4. Eco U. *The Open
Work* (1989) (first
published 1962)

'...the richest form of communication – richest because most open – requires a delicate balance permitting the merest order within the maximum disorder.'

In this case the order is symmetry, a simple form of probability. The reader now has some visual reference points which can be connected together to suggest a way of reading the image. Although the image still offers a good deal of freedom to the reader in terms of interpretation they now have some direction. If we were to shred the paper, make paper pulp and roll it out to dry as a sheet again there would be a huge number of dots and marks across the surface of the paper. The reader could begin to connect these marks in an infinite number of ways, but there would be no discernible direction for the reader. The image is now extremely open and contains a maximum amount of information but is utterly meaningless. We are not likely to make one reading of the information above another. What we have is the visual equivalent of white noise.

This excess of possibilities does not increase the information but denies it altogether. It doesn't communicate. Eco uses this as evidence that:

'...the richest form of communication – richest because most open – requires a delicate balance permitting the merest order within the maximum disorder.' [5]

He maintains that this is a characteristic of any visual communication, which wants to be understood, but also wants to allow a degree of freedom to the reader. He points out how the intention of the author may be enough to give the work a value. As we saw in chapter 8 **junk and culture** a piece of discarded material can become an artefact once it has been framed. Our pavements and roadways are peppered with cracks and holes. Some of these are framed with brightly coloured squares painted by the highways agency to mark their priority for repair. This visual signal shows us that these cracks have been chosen over other cracks, they have called attention to them. Merely by isolating them they have become artefacts.

148
▼

5. Eco U. *The Open Work* (1989) (first published 1962)

Much of what an artist does is to make choices. By choosing to isolate a particular part of a pattern we immediately make it an artefact.

> The mark does not merely stand for the action but it is the action. The gesture and the sign are fused together.

Form and Openness

Eco reassures us that the informal sign does not mark the death of form in the visual arts but proposes instead a new flexible form, which is a field of possibilities. The gestural marks and spatters of abstract painting stimulate the viewer to make their own connections in the work. Reading the original gesture which leaves this mark, is fixed by this mark, is in this mark, will lead us eventually to the intention of the person who made the mark. According to Eco it is this underlying intention which distinguishes a work of art from the patterns of the cracked pavement. The marks are the signifier of the gesture but not a symbolic sign for the gesture. The mark does not merely stand for the action but it is the action. The gesture and the sign are fused together.

Unlike symbolic signs which belong to a defined set of signs and whose meaning we have learnt, like road signs or letters of the alphabet, these abstract marks need interpretation. There is no predetermined collection of these signs. They could be considered analogue codes rather than digital codes like music or the gestural movements of dance. Eco argues that in allowing the reader to freely associate the signs they enjoy the experience of doing this whilst at the same time they enjoy the aesthetics of the signs. The reader searches for as many possible associations as they can in a game of pleasure and surprise, trying to interpret the intentions of the author as they do so.
Open work in the visual arts is, according to Eco, a guarantee of communication with added pleasure. The two things are connected together in a way not to be found in the reading of more conventional signs. When we read the road sign, whose meaning has been learnt, we read the message but rarely do we marvel at the aesthetics of the sign. Only those of us with a particularly strong industrial aesthetic would enjoy the effectiveness of the way the sign is made. Openness is pleasure. Our visual culture invites us to view the world as a world of possibilities.

Openness is pleasure.

Russell Mills
Extending Wings
open work

The piece is concerned with several separate but connected ideas that are the contextual anchors for much of Mills' work. For example, ideas inspired and informed by Walter Pater's phrase 'All the arts aspire to the condition of music' is referenced in the use of images of Chaldni's experiments. Following several discussions with Dr Robert Woof (Director of the Wordsworth Trust) about how one might visually portray Wordsworth's work with the most minimal means, Mills concluded that it could be best summed up by a bowl and a stone in juxtaposition. The stone stands for the given and that which cannot be disputed, *nature* and *mathematics*; the bowl represents what we make of these givens, *culture*.

Ian Mitchell
Chinese Whispers
open work

An online font design project based on the children's game 'Chinese Whispers' where a message is passed from one person to another in a chain sequence, eventually arriving back at source to be compared with the initial message.
Bespoke software was designed to enable the user to assemble the next letter in the chain with reference only to the last one.

Right – The basic geometric shapes available to the designer of letterform.

Below – Icons which describe the process of making and compiling the fonts.

Far Right – The template characters used as starting points. Five lower case whispers started by the letter 'a'.

Woodtype from
Outer Space
Erik Van Blokland
Netherlands

Half-baked, half-uncial
Tobias Frere-Jones
USA

Mentalist stencilist
Jonathan Hitchen
UK

Fluid Woodblock
David Crow
UK

Alef
Yaki Molcho
Israel

Opposite Page
A selection of characters taken from each of the completed fonts.

1

2

Jonathan Hitchen
Untiled 1
open work

An online project using
bespoke software which
enables the user to make
drawings based on a
small matrix of randomly
plotted points.

This Page
1. The tools diagram.
The structure of the
drawing is determined by;
the total number of
points, the amount of
space between the points,
the density of points, the
sequence in which they
are used and whether or
not they are joined
together.

2. Arbitrary Overlaps.
Four initial drawings
arbitrarily layered in CMYK.

3. A selection of initial
drawings. These are
generated automatically
by Untiled 1.

Opposite Page
A Series of 'Details';
CMYK drawings that have
been adjusted and sepa-
rated by hand.

3

The End

fade to white

references

Introduction

Von Bertalanfly L. *General Systems Theory* (1968) Braziller in Bolinger D. *Language the Loaded Weapon* (1980) Longman

Brody N. at the Graphic Directions Conference, London *Eye magazine* No. 1 Vol. 1 (1990)

Chapter 1

Chaffe W. *Meaning and the Structure of Language* (1970) University of Chicago Press

Wittgenstein L. *Philosophical Investigations* (1963) in Gablik S. *Magritte* (1970) Thames and Hudson

Zeman J. *Peirce's Theory of Signs* (1977) in Sebeok T. *A Profusion of Signs* (1977) Indiana University Press

Chapter 2

de Saussure F. *Course in General Linguistics* (1974) (1st edition 1915) Fontana

Jakobson R. and Halle M. *The Fundamentals of Language* (1956) Mouton

Chapter 3

de Saussure F. *Course in General Linguistics* (1974) (1st edition 1915) Fontana

Barthes R. *Elements of Semiology* (1968) Cape

Willis P. *Common Culture* (1990) Open University Press

Bourdieu P. *Language and Symbolic Power* (1991) Polity Press

Barthes R. *Mythologies* (1973) Paladin

Chapter 4

Barthes R. *Image, Music, Text* (1977) Fontana

Jefkins F. *Advertising Writing* (1976) MacDonald & Evans Ltd.

MacLuhan M. and Fiore Q. *The Medium is the Message* (1967) Allen Lane The Penguin Press

Chapter 5

Bourdieu P. *Intellectual Field and Creative Project* (1971) in Young M.F.D. *Knowledge and Control* (1971) Collier-MacMillan

Bourdieu P. *Language and Symbolic Power* (1991) Polity Press

Bloomfield L. *Language* (1958) George Allen

Galindo R. *Language Wars: The Ideological Dimensions of the Debates on Bilingual Education* (1997) University of Colorado at Denver

Livingstone M. *Pop Art* (1990) Thames and Hudson

Horn F.A. *Lettering at Work* (1955) The Studio Publications

Hutchings R.S. *The Western Heritage of Type Design* (1963) Cory, Adams and Mackay

Rand P. *A Designer's Art* (1985) Yale University Press

Foucault M. *The History of Sexuality* (1979) Penguin

Gautier T. (1811–1872) in Rand P. *A Designer's Art* (1985) Yale University Press

Willis P. *Common Culture* (1990) Open University Press

Austin J.L. *How to do Things with Words* (1955) Oxford Paperbacks

Chapter 6

Brake M. *Sociology of Youth Culture and Youth Subcultures* (1980) Routledge and Kegan Paul

Marsh P. and Rosser E. and Harré R. *The Rules of Disorder* (1978) Routledge and Kegan Paul

Manco T. *Stencil Graffiti* (2002) Thames and Hudson

Hurd D. (then Home Secretary) *Conference on Vandalism*, London (1988)

Home Office Research Unit in Coffield F. *Vandalism and Graffiti* (1991) Calouste Gulbenkian Foundation

Frank Coffield F. *Vandalism and Graffiti* (1991) Calouste Gulbenkian Foundation

Castleman C. *Getting Up: Subway Graffiti in New York* (1982) MIT Press

Criminal Justice (Scotland) Act of 1980 (Section 78)

Baker C. and Waddon A. *Vandalism: Understanding and Prevention* (1989)

Clarke R. (1978) in Coffield F. *Vandalism and Graffiti* (1991) Calouste Gulbenkian Foundation

Fuller M. *Flyposter Frenzy* (1992) Working Press

Storr R. *Two Hundred Beats Per Min.* (1990) in Robert Miller Gallery's *Basquiat Drawings* (1990) Bulfinch Press

Blinderman B. *And We All Shine On* (1992) in Celant G. *Keith Haring* (1992) Prestel

Banksy in Manco T. *Stencil Graffiti* (2002) Thames and Hudson

The Guardian 21st January 1991 4.1.3. Interview

Chapter 7

Willis P. *Common Culture* (1990) Open University Press

The General Household Survey (1983–6) (Cultural Trends p.51)

Marsh P. and Rosser E. and Harré R. *The Rules of Disorder* (1978) Routledge and Kegan Paul

Chapter 8

Douglas M. *Purity and Danger* (1966) Routledge and Kegan Paul

Culler J. *Rubbish Theory* (1988) in Culler J. *Framing the Sign* (1988) Basil Blackwell

Thompson M. *Rubbish Theory: the Creation and Destruction of Value* (1979) in Culler J. *Framing the Sign* (1988) Basil Blackwell

Sitwell S. *Agamemnon's Tomb* (1972) in Douglas M. *Purity and Danger* (1966) Routledge and Kegan Paul

Chapter 9

Eco U. *The Open Work* (1989) (first published 1962) Hutchinson Radius

Zeman J. *Peirce's Theory of Signs* (1977) in Sebeok T. *A Profusion of Signs* (1977) Indiana University Press

Eco U. *The Role of the Reader* (1981) Hutchinson Radius

bibliography

Austin J.L. *How to do Things with Words* (1955) Oxford Paperbacks

Baker, C. and Waddon, A. *Vandalism: Understanding and Prevention* (1989)

Barthes R. *Elements of Semiology* (1968) Cape

Barthes R. *Empire of Signs* (1982) Hill and Wang

Barthes R. *Image, Music, Text* (1977) Fontana

Barthes R. *Mythologies* (1973) Paladin

Barthes R. *The Pleasure of the Text* (1975) Hill and Wang

Bloomfield L. *Language* (1958) George Allen

Bolinger D. *Language the Loaded Weapon* (1980) Longman

Bourdieu P. *Language and Symbolic Power* (1991) Polity Press

Castleman C. *Getting Up: Subway Graffiti In New York* (1982) MIT Press

Chaffe W. *Meaning and the Structure of Language* (1970) University of Chicago Press

Cobley P and Jantsz L. *Introducing Semiotics* (1999) Icon Books UK/ Totem Books USA

Culler J. *Framing the Sign* (1988) Basil Blackwell

Douglas M. *Purity and Danger* (1966) Routledge and Kegan Paul

Eco U. *The Open Work* (1989) Hutchinson Radius

Eco U. *The Role of the Reader* (1981) Hutchinson Radius

Fiske J. *Introduction to Communication Studies* (1982) Routledge

Frank Coffield F. *Vandalism and Graffiti* (1991) Calouste Gulbenkian Foundation

Fuller M. *Flyposter Frenzy* (1992) Working Press

Gablik S. *Magritte* (1970) Thames and Hudson

Galindo R. *Language Wars: The Ideological Dimensions of the Debates on Bilingual Education* (1997) University of Colorado at Denver

Horn F.A. *Lettering at Work* (1955) The Studio Publications

Hutchings R.S. *The Western Heritage of Type Design* (1963) Cory, Adams and Mackay

Jakobson R. and Halle M. *The Fundamentals of Language* (1956) Mouton

Jefkins F. *Advertising Writing* (1976)MacDonald & Evans Ltd.

Livingstone M., (1990) *Pop Art,* Thames and Hudson

MacLuhan M. and Fiore Q. *The Medium is the Message* (1967) Allen Lane The Penguin Press

Manco T. *Stencil Graffiti* (2002) Thames and Hudson

Marsh P. and Rosser E. and Harré R. *The Rules of Disorder* (1978) Routledge and Kegan Paul

Rand P. *A Designers Art* (1985) Yale University Press

de Saussure F. *Course in General Linguistics* (1974) (1st edition 1915) Fontana

Storr R. *Basquiat Drawings* (1990) Bulfinch Press

Willis P. *Common Culture* (1990) Open University Press

Willis P. *Moving Culture* (1990) Calouste Gulbenkian Foundation

Young M.F.D. *Knowledge and Control* (1971) Collier-MacMillan

index

acknowledgements

Special Thanks
I would like to thank the following people for their unerring support and their patience;

Wendy, Drew, Ailsa and George Crow, Judy and Frank Pennington, Seel Garside and all the staff in the Graphic Arts Department at Liverpool School of Art and Design. Brian Morris, Natalia Price-Cabrera and Laura Owen at AVA Publishing.

Contributors
Many thanks to all the talented individuals who kindly contributed their work;

Airside, Sam Weihl and David Hand at Burn, Chris Brown, Paul Davis, Katy Dawkins, Ged Doyle, FSI FontShop International, Seel Garside, David Grossman, Steve Hardstaff, Guy Hawkins, Marion Deuchars, Jonathan Hitchen, James Jarvis, Lucy McLauchlan, Joe Magee, Russell Mills, Ian Mitchell, Yaki Molcho, Neil Morris, Alan Murphy, The Outlaws – Patrick Young, Johnny Hannah and Paul Farrington – Michael O'Shaughnessy, David Shrigley, Rob O'Connor at Stylorouge, Hilton Thompson, Russell Bestley and Ian Noble at Visual Research, Henning Wagenbreth, Ian Wright, John Young, Patrick Young, Lawrence Zeegan.

Picture Research
Seel Garside

Illustration
Emily Alston p16, 24, 35, 37
Michael O'Shaughnessy p14, 15, 16, 25

Photography
All photography by the author except;

(Magritte) p22, Los Angeles County Museum of Art C.A., USA / Bridgeman. ©ADAGP, Paris and DACS London 2003
(Broodthaers) p23, ©Tate London 2003, DACS London 2003
Seel Garside (no.3) p33, (stars and stripes) p34
Takashi Homma (Perverse) p48, 49
Mrs Musgrove (graduation picture) p92
(Basquiat) p119, James Goodman Gallery, New York, USA. ©ADAGP, Paris and DACS London 2003
Matt Squire p121
A. J. Wilkinson p129

(DuChamp) p157, Cameraphoto Arte Venezia/Bridgeman. ©Succession Marcel DuChamp/ ADAGP, Paris and DACS London 2003
Janette Beckman (Ian and Connie Wright) p159
Eishun @ Issey Miyake (private view shots) p159
Wendy Pennington p171

The photographs on p111, 113, 115, 152 are reproduced with the kind permission of F-Stop images, FSI FontShop International

Contacts

Airside
info@airside.co.uk

Burn
info@burneverything.co.uk

Paul Davis
bigorange@btclick.co

Katy Dawkins
katydawkins@yahoo.co.uk

Marion Deuchars
mariondeuchars@lineone.net

FSI
www.FontFont.com
www.fStopImages.com

Seel Garside
www.beaufonts.com

Jonathan Hitchen
www.beaufonts.com

James Jarvis
jj@worldofpain.com

Lucy McLauchlan
lucymc@uk2.net

Joe Magee
www.periphery.co.uk

Russell Mills
mills@matter-shed.co.uk

Ian Mitchell
www.beaufonts.com

Yaki Molcho
rutyaki@mail.shenkar.ac.il

Neil Morris
N.Morris@livjm.ac.uk

Alan Murphy
al@murphykid.com

Michael O'Shaughnessy
mickeyshona@hotmail.com

Stylorouge
www.stylorouge.co.uk

Visual Research
visualresearch@hotmail.com

Henning Wagenbreth
www.tobot.com
mail@tobot.com

Ian Wright
mail@mrianwright.co.uk

Lawrence Zeegen
z@zeegen.demon.co.uk